Setsuko MIGISHI

S. Migishi

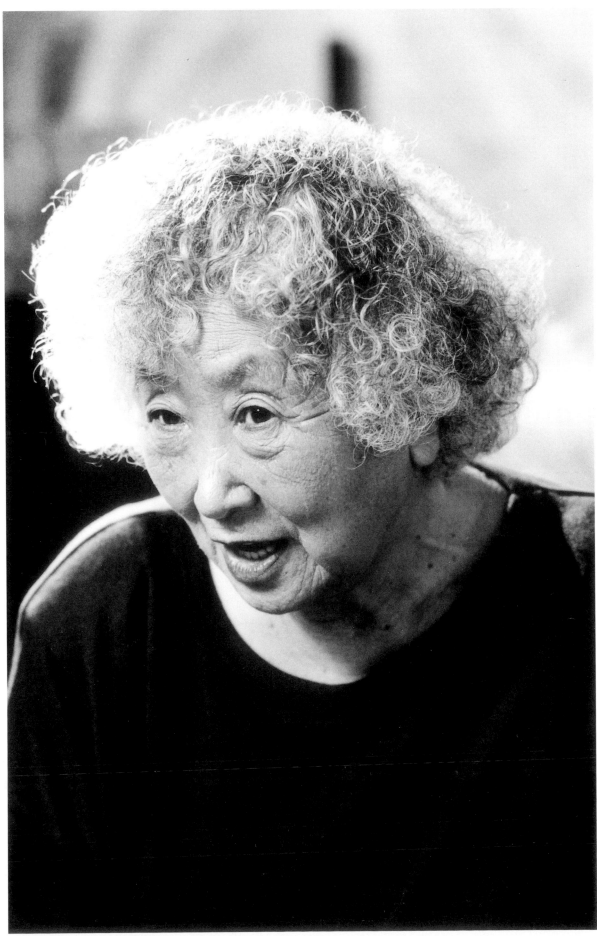

Photograph by Kazuo Nagumo

Foreword

We are delighted to present this 66-year retrospective of the art of Setsuko Migishi, Japan's foremost woman painter in the Western style.

Ever since the time, three years ago, when the Asahi Shimbun and the National Museum of Women in the Arts first cooperated in cosponsoring an exhibition of the work of Camille Claudel at the Museum, they have shared a common ambition: to hold an exhibition of the work of some outstanding Japanese woman artist as one small contribution, via the universal language of art, to cultural exchanges between the United States and Japan. That ambition has finally been realized in the present exhibition. We are deeply interested to see what impression the work of this artist, which has its ultimate roots in the traditional culture of Japan, will make on the American public.

This exhibition was preceded by an exhibition of "Four Centuries of Women's Art" from the National Museum of Women in the Arts, which began a tour of eight venues in various parts of Japan in August last year. Works by 82 women artists from countries throughout the world—women who fought against a variety of restrictions to give expression to their unique talents—are being presented to the Japanese public along with brief accounts of their lives, and are provoking an enthusiastic response.

By now, the number of women in Japan who live independent lives, giving expression to their own personal beliefs, has increased greatly. Half a century or more ago, however, when Japan was more feudal in its attitudes, it was no easy task for a woman to carve out a life for herself as an artist. Setsuko Migishi, who celebrated her 86th birthday on January 3 this year, made her debut in 1925 when she became the first woman to have a work shown in the Shunyo Society's Exhibition, and from that time on a combination of fierce passion and patient effort has carried her on, winning her a secure position in the world of Western-style painting in Japan.

Her husband Kōtarō, a respected artist in his own right, died at the early age of 31. Left with three children to rear, she continued to produce a steady succession of works, at the same time calling for a sense of comradeship among women artists. In 1946, the year following the end of the war, she formed the Women's Art Association. In a sense, the path that she opened up for herself as a pioneer of women's art in Japan was a painful one. At the age of 63, a time of life when she was securely established, with a reputation sufficient to give her complete freedom of action, she gave up her home in Japan and, acquiring a studio in France, proceeded to immerse herself in creative activity completely apart from the world of Western-style painting in Japan. Since her return to Japan two years ago, she has continued to paint every day at her studio in Ōiso, overlooking the Pacific Ocean. Her lifelong devotion to the strict demands of her own art has been an inspiration to large numbers of Japanese women.

We hope that this exhibition will contribute to a sense of fellowship between the women of the USA and Japan; and we pray that the National Museum of Women in the Arts, that shrine to women artists all over the world, will go on to new heights in the years to come.

<div align="right">The Asahi Shimbun</div>

The Sensitive and Courageous Art of Setsuko Migishi

Hideo Takumi

The "opening" of Japan to the West following 1854 had major repercussions within all levels of society and for every business and profession. The country's new policy of Westernization quickly and dramatically changed many traditional features of Japanese culture. It was not until two generations later, however, that professional artists began to have major group exhibitions and to achieve a respected position in society.

For women artists the road to acceptance was more difficult. Japanese women had to contend with strong sexual discrimination until after World War II, when a democratic constitution gave women the right to vote and guaranteed them other civil liberties.

Throughout her sixty-six-year career, Setsuko Migishi has been a pioneer among Japanese women artists. In 1925 she was the first woman invited to participate in a show by the respected artists' group Shun'yō-kai. In 1935 she was the first woman to receive a prize from another major artists' group, the Dokuritsu-bijutsu-kyōkai. She became the first female member of the Shinseisaku-ha-kyōkai in 1939. Eleven years later,. in 1950, she won the Geijutsu Senshō, becoming the first woman to receive this illustrious art prize awarded by the Minister of Education.

Migishi achieved success in spite of great adversity. She married young, but became a widow in 1934 at the age of twenty-nine. Left with three children to raise, she struggled to earn a livelihood during a period when there were few jobs available for artists and paintings did not command high sums, except for a few grand masters' works. Under these circumstances, her continuing commitment to art required courage, will power and talent.

The paintings of Setsuko Migishi reflect the profound influence that French art has had on the development of contemporary Japanese painting. Her early canvases recall Henri Matisse's sophisticated use of color and the feathery quality of Raoul Dufy's line. Her style of the 1940s is reminiscent of Pierre Bonnard's intimate genre scenes. Her art from the 1950s on shows the influence of Georges Braque.

Migishi first established her reputation as a still-life painter. In 1968, when she visited Europe for the second time, she became interested in landscapes, and her well-known series of Venetian landscapes was inspired by that trip. Since the late 1980s she has moved on to depict the ruggedly evocative hills and villages of Andalusia, Spain.

Now eighty-six years old, Setsuko Migishi continues to develop and replenish her art. The works she has created during a career marked by struggle and conflict contain strength, harmony and balance—some of the very qualities that have enabled her to achieve so much.

—— Director of The Museum of Modern Art, Ibaraki

Translated by N.M.W.A.

Migishi and the Eternal Spring

Roger Bouillot

There are few artists in this century whose work explores one of the fundamental questions of art—Should it express what the artist feels or reflect its era? Setsuko Migishi is one of those great painters whose work addresses this basic question and offers a twofold response. Her art gives voice to a singular spirit, simultaneously expressing that which is essential to our era and that which connects us with the timeless, immutable truths. Her art explores the basic anxiety of life and the immeasurable totality of the human drama.

Before discussing Migishi's work further, it is appropriate to speak of her character. Everything about this small woman who is a great lady—her Japanese femininity, her professionalism and the radiance of her work—conveys the nobility of her spirit and the strength of her beliefs.

As a Japanese woman artist, Migishi expressed early on the pioneering spirit so characteristic of her work. It required unshakable conviction to become a painter in the Japan of the 1920, let alone to strive for the increased recognition of Japanese women artists. In 1936 she formed the first organization for women artists, the Shichisaikai. This group of seven members grew into the Association of Women Painters in 1946 and later the Ushio Salon in 1969. In the Japan of today, which reveres its past—a fascinating thousand-year civilization—and devours its present with equal vitality, Migishi personifies the future of women in art. This future is not tied exclusively to her homeland.

Migishi first gained recognition in Japan in 1950. She became better known a year later, when she was selected to represent Japan at the São Paulo Biennial in Brazil, followed by the May Salon in Paris and the Carnegie International exhibition in Pittsburgh, Pennsylvania. A major turning point in her life and in her art occurred in 1954, when she resided in Paris for a year. In 1955 she moved to the Riviera, living in Cagnes-sur-Mer on the Côte d'Azur, a port city bathed in the incomparable light of the Mediterranean. Later, in 1974, she settled in Véron, Bourgogne, where she remained for roughly fifteen years. Thus, for nearly a quarter of a century the light of France has served as the basis for her creative meditations.

A landscape artist, Migishi has drawn her inspiration from the countryside—from Provence, the south of Spain, Bourgogne and the area around Venice. It is significant that her landscapes contain no human figures, as if to eliminate the human scale and emphasize the immediate physicality of rooftops, red earth, mysterious canals, alleys and blocks of houses. These deserted landscapes have a timeless quality in which memory is immobilized and light grows heavy, to the point of isolating the viewer. Migishi's canvases exude a sculptural sense, defining the landscape with a section of a wall, the corner of a fountain or part of a roof. Though her scenes are devoid of human presence, they nonetheless resonate with the indelible traces of life in all its stages, vestiges of transformations and diffuse memories.

Having said this, it is necessary to emphasize the great variety of Migishi's subjects and the different treatments she uses. Her style reveals an inner freedom that seems to elude Western logic and analysis. Each work contains a core of mystery which is never truly elucidated. Taken together, however, the paintings seem to radiate light, which explains the magical quality of certain night scenes and the almost bewitching effect of the bouquets and flowers.

"More Flowerlike than Flowers" is the title of an essay on Migishi's art published in Japan in 1977. I have immense admiration for her flowers, works that demonstrate great variety both in form and use of color. For each canvas she employs only two or three colors with judicious intensity. Silent prayers, frozen dreams, joyous offerings—Migishi's flowers speak of the great adventure of the seasons, the cycle of the ages, the love which molds human existence from eternity. In her flowers Migishi demonstrates most subtly one of the major characteristics of her art, a radiance that is almost meditative. An intense vibrancy and a soothing harmony flow simultaneously from the communion of her inner spirit with nature, from the primordial intuitions of the earth mother reckoning the certainty of the eternal return of spring. Like other artists before her, Setsuko Migishi has enriched of the history of art with contributions which are strongly feminine yet fundamentally human.

Like many painters before her, Setsuko Migishi has enriched the history of art with contributions which are specifically feminine yet fundamentally human. Her achievements manifest a subtle and radiant spirituality.

Translated by N.M.W.A.

Migishi et l'éternel printemps

Roger Bouillot

Ils sont peu nombreux les artistes de ce siècle dont l'œuvre pose la seule vraie question de la peinture : doit-elle exprimer, et donc privilégier ce que l'artiste ressent, ou bien doit-elle témoigner, et avant tout refléter son époque? Et plus généralement l'inquiétude fondamentale des êtres. le drame humain dans son incommensurable totalité.

Migishi est l'un de ces maitres dont l'œuvre pose la question et offre la double réponse. Sa peinture exprime le message d'une âme singulière et dit simultanément ce qui est essentiel pour notre époque, ce qui la relie à la vérité intemporelle, voire au temps immobile.

Avant de parler de l'œuvre, il convient de s'attacher à l'attitude d'artiste. Chez cette femme menue qui est une grande dame, tout me semble dominé par la noblesse du cœur et l'exigence spirituelle : la japonaise, l'artiste de notre temps, le rayonnement immanent de l'œuvre.

Femme et japonaise, Migishi manifesta très tôt un véritable esprit pionnier, caractérisé par un altruisme persuasif. Dans le Japon de 1920, il lui fallut une vocation inébranlable pour décider d'être peintre, puis d'œuvrer, de militer pour la reconnaissance du pouvoir créateur de la femme japonaise en suscitant en 1935, un premier groupe de sept artistes féminins, le Shichisai-kai, puis en organisant l'Association des Peintres Féminins dès 1946 et le Salon Ushio à partir de 1969, Dans le Japon d'aujourd'hui, qui vit intensément son passé —immense et fascinnante civilisation millénaire— et dévore son présent avec une intense vitalité, tout en le conjuguant déjà avec le XXIème siècle, Migishi montre l'exemple de ce que sera la femme artiste dans la société future. Pas seulement celle de sa patrie.

Migishi est une très grande artiste de notre temps. Cela commença d'être reconnu dès 1950 dans son pays et plus encore avec sa désignation, l'année suivante, pour représenter le Japon à la Biennale de São Paulo, Il y eut ensuite le Salon de Mai à Paris, l'exposition du Prix Carnegie.

Un tournant considérable de sa vie, et de sa création est constitué par le séjour à Paris de 1954, celui de 1955 sur la Côte d'Azur, à Cagnes-sur-Mer, et son installation dans ce petit port méditerranéen que baigne une lumière incomparable. En 1974, quand Migishi se fixera en Bourgogne, à Véron, ce sera pour y séjourner une quinzaine d'années. Au total, durant près d'un quart de siècle, ce sont les lumières de France qui serviront de départ à sa grande méditation créatrice.

Paysagiste, Migishi a surtout puisé son inspiration en Provence, en Espagne du Sud, dans sa Bourgogne, ainsi qu'à Venise. Il convient toujours de le remarquer, ses paysages sont dépourvus de personnages, comme pour les préserver de l'échelle humaine et privilégier l'impression d'ensemble de ses toits groupés, de ses terres rouges, des mystérieux canaux, des ruelles ou des blocs de maisons, et les situer hors du temps des horloges, dans une autre dimension temporelle où le souvenir

s'immobilise, où la lumière s'appesantit sur les choses au point d'isoler la pensée du spectateur loin du moment qui rythme son cœur. Dans le voisinage de sa pensée plastique, il faut placer toutes les admirables toiles de Migishi où le paysage se résume, et se concentre, en un pan de muraille, un coin de fontaine, un fragment de toit. Là encore nulle présence humaine, mais la trace indélébile de la vie dans ses étapes, ses métamorphoses ou son souvenir diffus.

Ceci posé, il est nécessaire de souligner la grande variété des sujets et de leurs différents traitements, révélateurs chez l'artiste d'une liberté intérieure qui échappe peu ou prou à notre logique occidentale, et plus encore à la volonté d'une analyse plastique selon les critères habituels. Chaque œuvre détient une part considérable de mystère, pas vraiment élucidée quand on remarque la constante de toutes les peintures la lumière semble émaner de l'œuvre elle-même, elle obéit à une irradiation interne indéfinissable qui explique, par exemple, la magie immobile de certains nocturnes, la présence fascinante quasi envoûtante des bouquets et des fleurs de Migishi. "Fleurs plus vraies que nature" est d'ailleurs le titre d'un essai qu'elle a publié au Japon en 1977.

J'ai une immense admiration pour les fleurs de Migishi, œuvres d'une très grande variété dans sa grammaire des formes comme dans l'étendue de la palette. Pourtant chaque toile est traitée en seulement deux ou trois couleurs d'une judicieuse intensité. Prières muettes, rêves figés, offrandes joyeuses, les fleurs de Migishi disent la grande aventure des saisons, la ronde des âges, et métamorphosent en amour ce que le temps humain soustrait à l'éternité. C'est dans ses fleurs que Migishi manifeste le plus subtilement le caractère majeur de son art, proche de la force rayonnante des contemplatifs. Harmonie vibrante puis apaisante, venue d'une communion puissante de son être intérieur avec la Nature, d'une intuition primordiale de la Terre-mère dans l'ardente certitude de l'éternel retour du printemps. Comme autres artistes avant elle, Setsuko Migishi a contribué à enrichir l'histoire de l'art d'un apport spécifiquement féminin, considérable et humainement bénéfique.

Setsuko Migishi: The Artist and Her Art

Yasuto Ota

Setsuko Migishi was born in the city of Bisaishi in Aichi prefecture, a few hours west of Tōkyō, in 1905. The city lies along the banks of the Kiso River, which provides an ample supply of water. Since the 8th century, when the capital of Japan was in Nara, the area has been blessed with beautiful lush rice fields. It is also an old commercial center boasting a flourishing weaving industry since the end of the Middle Ages. Setsuko's family, the Yoshidas, had been well-to-do local landowners for generations. At one point, as woolen manufacturers, they ranked among the wealthiest families in the prefecture.

Although surrounded by material comforts from birth, Migishi suffered from a congenital dislocated hip. She recalls that, because of this infirmity, she was a lonely child to whom her mother did not show much affection. In an autobiographical essay titled "The Struggle to Become a Woman Painter" (Joryū gaka no chimidoro no michi), she reminisces about her childhood as follows: "When people gathered at our house for an event, I was placed in the storehouse out of concern for the family's reputation as local landowners. . . . As a young child in grammar school, my infirmity tormented me. An inferiority complex, rebelliousness and an indomitable spirit were already etched in my character from the time I first became aware of what was going on around me."

She displayed no interest in sewing or the tea ceremony, accomplishments that her parents encouraged her to take up. Instead, she developed into an undomesticated girl who possessed considerable knowledge. While attending Shukutoku Girls' High School in Nagoya, where she lived in a boarding house, she became addicted to novels. Under the influence of an older student who aspired to become a Japanese-style (Nihonga) painter, her interest in painting also deepened during that period.

In 1920, Migishi's fourth year at the school, the fortunes of the Yoshidas suffered a terrible reversal when the family woolen factory went bankrupt in the panic that occurred on the heels of World War I. The financial ruin and anguish suffered by her venerable landowning family, however, only reinforced Migishi's rebellious spirit. Following her graduation from high school, she set out for Tokyo, after having even resorted to a hunger strike to overcome her parents' opposition. In 1921 she began studying under Saburōsuke Okada, the director of the Hongō Institute for Western Painting (Hongō Yōga Kenkyūjo).

In 1922 Migishi enrolled as a second-year student in the Women's Arts School or Joshi Bijitsu Gakkō (now the Women's College of Fine Arts or Joshi Bijutsu Daigaku), headed by Okada. Migishi demonstrated her future talent by graduating at the head of her class. In spite of her success, however, she was dissatisfied with the school, which seemed like an extension of a girls' academy. She began to lead the life of a modern dissolute student (what one would have

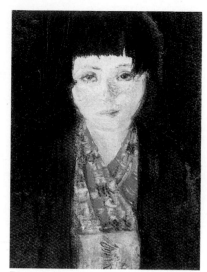

Pl. 1. *Self-Portrait* 1925

Fig. 1. *Landscape* 1925

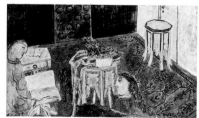

Pl. 3. *Interior* 1936

called a flapper in America). In her rebelliousness, she frequented the Asakusa entertainment district and made the rounds of exhibitions, movie theaters and coffee shops.

Migishi met her future husband, the up-and-coming artist Kōtarō Migishi, while leading this bohemian existence during her student days. In the spring of 1924, Kōtarō took first prize at the Shun'yōkai Association exhibition. Migishi's respect for the talent of Kōtarō, who was oblivious to poverty, soon developed into love. "I did not have the slightest idea what poverty was really like," she recalls in her memoirs. "The lure of adventure, indiscriminately elevated into something exalted, helped, and I flew into his arms." Overcoming her parents' opposition, she married Kōtarō the year she graduated from school, and her older daughter, Yōko, was born the following January.

Migishi's life with Kōtarō continued until July 1934, when he suddenly collapsed and died while on a trip to Nagoya. In those days oil paintings had little commercial value, and the couple, who had three children, suffered from extreme poverty. Migishi also suffered from the philandering of Kōtarō, who maintained that he was unable to paint unless he pursued women. She later confessed that, toward the end, she even contemplated suicide. It was Kōtarō's influence that eliminated the academic qualities in Migishi's art and transformed the rebellious girl into a true artist. "During my twenties," she would later recall, "my bitter experience living with Kōtarō amounted to cruelty, but I learned what art was really about. I acquired a vague notion of the sufferings that people undergo in this world. It was a valuable, irreplaceable decade."

Not many of Migishi's works prior to World War II survive. For one thing, she was frantically busy raising three children and looking after her mother-in-law and sister-in-law. Also, after Kōtarō's death, she was forced to undertake all sorts of jobs just to scrape by. She produced magazine illustrations, participated in round-table discussions, gave lectures, and wrote articles, since artists of the day could not live by selling their paintings. All the same, she tenaciously continued painting and exhibiting her work.

Self-Portrait, 1925, which was produced when Migishi was pregnant with her first child, is an outstanding work that expresses her girlishness and strong passion. Along with *Landscape* (Fūkei), *Sasanqua*, which depicts a kind of plant and *Two Pieces of Fruit on a Table* (Takujō no nika), it was selected for inclusion in a Shun'yōkai Association exhibition which marked her debut in the art world. Shōhachi Kimura, one of the founders of the association, described her work as "a flawless gem", with which no man's paintings could compare. The reputation that her talent surpassed that of men was a constant refrain thereafter.

The distinctive outlines of Migishi's art began to take concrete form around 1934, the year her husband died. In particular, *Interior*, 1936, displayed at the Independent Artists exhibition was a tour de force that led to her becoming an associate member of that group. She herself describes it as one of her best works. Paintings of interior scenes featuring a palette reminiscent of Henri Matisse's formed the core of Migishi's artistic output for *Exhibition of New Interior Paintings* and the *Private Exhibition of Watercolor Paintings Depicting Interior*

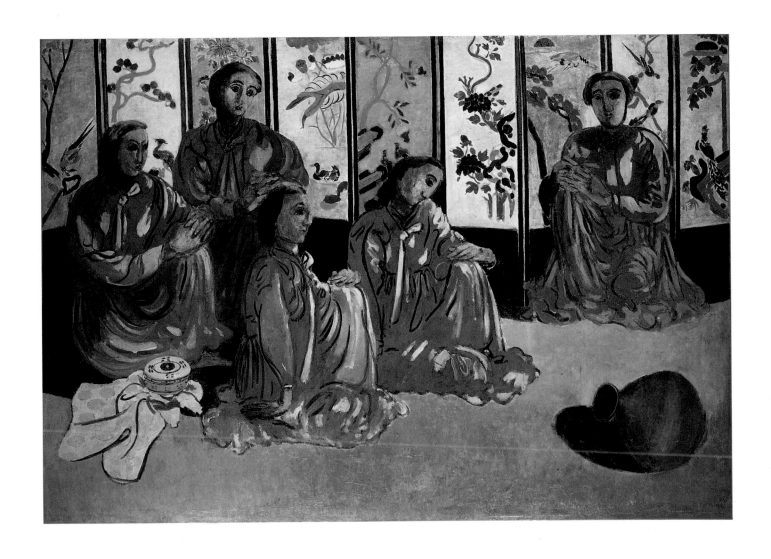

4.
朝鮮取材（習作）
Korean Study
1940

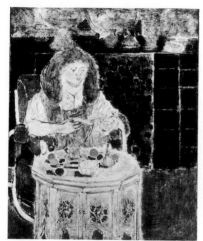

Fig. 2. *Interior* 1942

Fig. 3. *Crystal (Blue)* 1949

Fig. 4. *Still Life* 1949

Scenes held at the Galerie Nichidō in Ginza, an area of downtown Tokyo, in 1937 and 1938, respectively. Still lifes of a table in a corner of a room formed another common theme in Migishi's pre-World War II paintings.

In the late 1930s Migishi was living in a very modern atelier that Kōtarō had designed shortly before his death with the architect Iwa Yamawaki, a friend who had studied at the Bauhaus. The atelier was overrun with odd junk and exotic curios that Kōtarō had collected. Using such objects as a motif, Migishi carried on her husband's modern dream and romantic vision in the casual everyday environment in which she lived. When the liberal, urban outlook of Taishō modernism retreated into darkness, the idea of creating a fictional decorative space by means of these specially chosen objects changed into an attachment to all aspects of the interior as a form of escape. In this sense, her work approached the *intimisme* of Pierre Bonnard.

Speaking about *Interior*, 1942, which Migishi categorized as a work from the last part of a long period devoted to depicting interiors, she explains, "I eliminated the window frame altogether, and treated the interior and exterior space as one. The exterior consists of a white wall and the sky glimpsed slightly, in a suggestive manner, above it. The interior depicts a chair; an octagonal table on which a tablecloth, flower vase, and flowers have been placed; a black cat on a cushion facing away from the observer; and a girl in a red dress. I tried to evoke this happy interior scene by means of the color arrangement. . . . In those days the world beyond the walls of the house was depressing; the times were not conducive to painting such pictures. This sort of scene existed only in the atelier. Painting pictures provided my only consolation."

In September 1945, only a few weeks after World War II, the first private exhibition was held at the Galerie Nichidō in Ginza, which miraculously had survived the air raids. The fact that the exhibition was devoted to the works of Migishi is indicative of the attention that centered upon her as one of the women at the forefront of the new age after the war. In 1946, the year that Women's Suffrage went into effect in Japan, the Association of Women Painters, an independent organization with open membership, was launched. Although the defeated nation suffered from material hardship, good times had indeed arrived for women painters.

Casting off the drab look of the war years, this period of Migishi's art became brighter and more colorful. Her paintings reveal a more realistic, constructive frame of mind, replacing the fictional arabesque interiors with a decorative color and line that reflected the influence of Raoul Dufy and Matisse. These works also display a heightened interest in life force emanating from within the objects she is depicting.

With the advent of the 1950s, Migishi's paintings began to take on another new aspect. The environment around her changed once Japan was well on the road to recovery from the devastation caused by the war, and international art trends began to be reintroduced after the hiatus caused by the war. Moreover, transitional paintings such as *Crystal* (Blue) and *Still Life*, both works from 1949 now in the Nagoya City Art Museum, show the influence of the painter

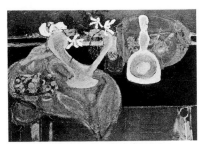
Fig. 5. *Still Life (Gardenia)* 1950

Keisuke Sugano, whom Migishi had married the previous year. Migishi first met him in 1937, when he held an exhibition at the Galerie Nichidō of paintings he had done in Europe. An artist with an unusual career, Sugano dropped out of the French Literature Department at Kyōtō University and went to France in 1935, where he studied under Jules Léon Flandrin. Sugano's paintings in those days focused completely on towns in northern Europe, such as Warsaw and Heidelberg. He produced unusual works that evoked an romantic lyricism through pure, simplified forms. "His paintings were completely different from anything found then in the Japanese art world," exclaimed Migishi. "They were unusual. The contents were poetic, and the paintings had a distinctive flavor, a perceptible fervor. The paintings with their deep hues were steeped in romanticism."

During the war the couple carried on a clandestine relationship because Japanese society frowned upon the remarriage of widows while the country was at war. They parted from him for a while, but met again after the war and married in 1948. It is difficult today to assess the extent of Sugano's influence on Migishi, as almost none of Sugano's paintings survive. In any event, the formalization of their relationship brought Migishi emotional stability, and their years together were fulfilling ones for her until the marriage collapsed in 1953 due to Sugano's infidelity.

In the 1950s the compositions in Migishi's paintings became even livelier and more modern. The number of motifs she employed decreased, and each one was treated more prominently on the canvas. Unusual, complex shapes gave way to objects with simple, pure forms that exuded a forceful presence, as her interest shifted from arabesques on the canvas surface to the interaction between form and space. The earlier warm tones, such as red, yellow and orange, likewise gave way to more subdued colors centering on brown, black, white, green and gray.

The influence of the polished sense of form and color in Georges Braque's still lifes is evident in Migishi's work of the 1950s. This style of painting heightened her stature in the art world, and commercial recognition followed, enabling her finally to leave the years of financial struggle behind. The Japanese Ministry of Education bought her still life *Goldfish,* one of six paintings she showed at the Fourteenth Shinseisakuha (Association of New Works) exhibition in 1950. The Japanese Minister of Education Award went to *Gardenia* (Kuchinashi) and that autumn the art magazine *Geijutsu shinchō* ranked her fifth on a list of the top ten painters in Japan. She was the only woman on the list. She also began to represent Japan internationally. In 1951 she was chosen to represent Japan at the São Paulo Biennial in Brazil; in 1952 she participated in the Salon de Mai in Paris and in the Carnegie International exhibition in Pittsburgh, Pennsylvania. "It was the pinnacle of my career as a painter," she recalls. "During that period I experienced a sense of fulfillment."

Even by then, however, signs presaging a major change in Migishi's work could be found. For instance, the first published collection of her paintings, brought out by Bijutsu Shuppansha in March 1954, contained an overview of her work by the art critic Sōichi Tominaga. In it he wrote the following about Migishi, who was almost fifty:

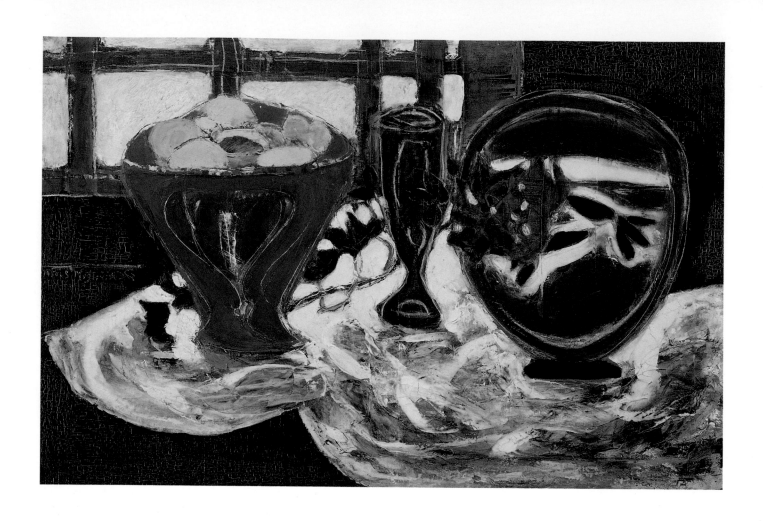

9.
静物（金魚）
Still Life
1950

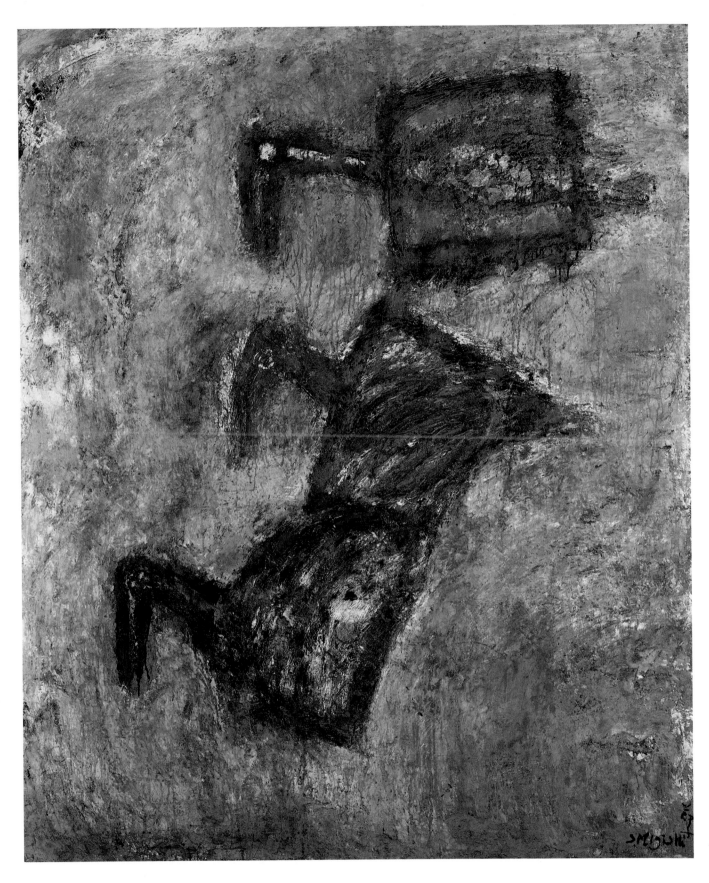

25.
飛ぶ鳥（火の山にて）
Flying Birds
1962

Fig. 6. *Gardenia* 1953

Fig. 7. *Captured Bird* 1953

Fig. 8. *Clouds in Motion* 1953

This woman's eye has fixed unwaveringly on the idea of modern form that runs through the works of Matisse, Bonnard, and Braque. She has established her own artistic identity, while constantly confronting their modeling of space and sense of color. The passionate clash has taken root as the emission of a fresh sensibility and as the embodiment of Migishi's art. Spectators recognize, appreciate, and applaud it. At this juncture, Migishi would probably like to take a deep breath and plunge the sharp edge of that sensibility into a new aspect of painting. An effort in that direction can already be discerned in her work during the past year or two. For instance, in *Gardenia*, 1953, *Captured Bird*, 1953, and *Clouds in Motion*, 1953, she seems to be seeking another positive direction, in perpetual motion while resting on the same foundation as her previous work. Migishi apparently is about to leave for France; by the time this book is published, she may already be there. It will be most interesting to see what the new setting for the senses that Migishi discovers there bestows on this observant woman. The timing is perfect for Migishi to take a trip abroad.

Migishi took her first trip to France in the spring of 1954. The collapse of her marriage to Sugano the year before had left her deeply de pressed, and so the trip may well have signified for her a way of pulling herself together and starting out anew. In Paris she met her son, Kōtarō, who had been studying painting there since the previous year. Afterwards she went to Spain and then visited Cagnes-sur-Mer in southern France. She even went to Italy. She returned to Japan in July 1955, having fulfilled a long-standing dream of seeing Europe.

Following Migishi's first visit to France, works such as *An Old Quarter in Paris* (Pari no furui machi) and *Mimosa Blooming in Vallauris* (Mimoza saku Vallauris) were shown at an exhibition of her French paintings held at the Umeda Gallery in Ōsaka and the Kabutoya Gallery in Tōkyō. The compositional sketches featured boldly simplified and distorted shapes, previously glimpsed in her still lifes. Now, however, these forms were applied to a new genre: landscapes.

The most important result of this initial visit to France was Migishi's first self-conscious attempt to create "paintings produced by a Japanese artist," a goal stimulated by her observation of Western art in its own setting. The unglazed pots on display in the Near Eastern section of the Louvre particularly impressed her. After returning to Japan she happened to come across a display of *haniwa*, burial-mound figurines made of clay, at the Tōkyō National Museum. The figurines struck her as an expression of "pure, unadulterated Japan," and she began collecting and using them as a motif. This development bespeaks the birth of a desire for a simple, primitive expression of humanity, inspired by the recent journey, on the part of Migishi, who previously had pursued the polish and urbanity of modernism based on modern French painting.

It is quite likely that at this juncture she felt a desire to study contemporary art, as her twenty-three-year-old son was doing. In fact, her essay "Bidding

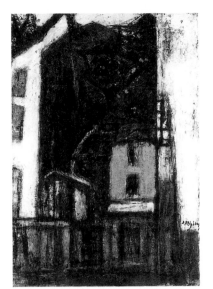

Fig. 9. *An Old Quarter in Paris* 1954

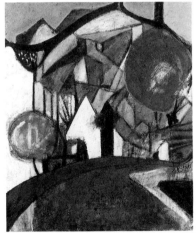

Pl. 14. *Mimosa Blooming in Vallauris* 1954

Farewell to Japan" (Nihon e no ketsubetsu), published in the May 1954 issue of *Geijutsu shinchō*, quotes repeatedly from her son's letters, which doubtless reflected the new trends in the Paris art scene, such as the Art informel movement. In that essay she quotes him as saying: "The most splendid items in the Louvre were the Near Eastern pots. The modern age is moving in the direction of this sort of simplicity." At another point he says, "Modern painting is closer to the Orient; the belief that new modern painting will inevitably begin in the Orient means that modern painting must become more spiritual." He also writes, "The time has long since passed for perceiving and expressing things visually. In modern times, the spirit itself must be frankly expressed; it must be completely bared." After she returned to Japan, Migishi would espouse some of these same views.

Starting with the 1956 Shinseisaku Artists exhibition, Migishi began to show works using haniwa figurines as a design element. The strong lines delineating the composition in her paintings of haniwa form a link with her paintings created prior to her French landscapes. This technique, however, conflicted with her desire to break away from principles of modern art that had held sway since Cubism. Migishi was trapped within a framework of her own making, in spite of "fervently desiring to create new paintings, to create fresh paiutings" under the influence of new surroundings. A more thorough-going sort of spiritual descent into hell, seemed necessary. In 1957 she began living alone in a villa house in the mountain resort of Karuizawa, where she concentrated on painting. She describes the adventure, which verged on a spiritual crisis, as follows:

> Cutting off all ties with the outside world, I imposed upon myself a life restricted to the atelier. It was possible to do so in Karuizawa during the off-season. I was able to maintain my isolated life. My only companion besides my paintings was the silent world of nature around me.
>
> But the life of solitude in Karuizawa was also a painful time of trial. Thoughts of my own foolishness, the emptiness of existence, feelings of remorse and shame, gnawed at me. Agony and groans wrenched my soul. Sometimes, the emotions stole over me, like a layer of mist overtaking a mountain, and then vanished like the wind.
>
> I wanted to produce paintings that I could live with. I vowed to continue the pursuit until I was satisfied. The happiness and contentment [caused by the fact] that satisfaction seemed within my grasp would suddenly vanish, or collapse, and I would fall prey to yet another demand. Happiness vanished instantly; the pain and despair, alone, persisted.

The outcome was a series of paintings called *Fire Mountain* (Hi no yama nite), which were first displayed at the 1960 Shinseisaku exhibition and then at a private showing. The paintings depicted pheasants that visited her garden and the grandeur of nearby Mount Asama, which spewed forth smoke and, sometimes, fire. The birds and mountain, simplified and abstracted to an extreme degree, were painted with colors verging on a brown monochrome that

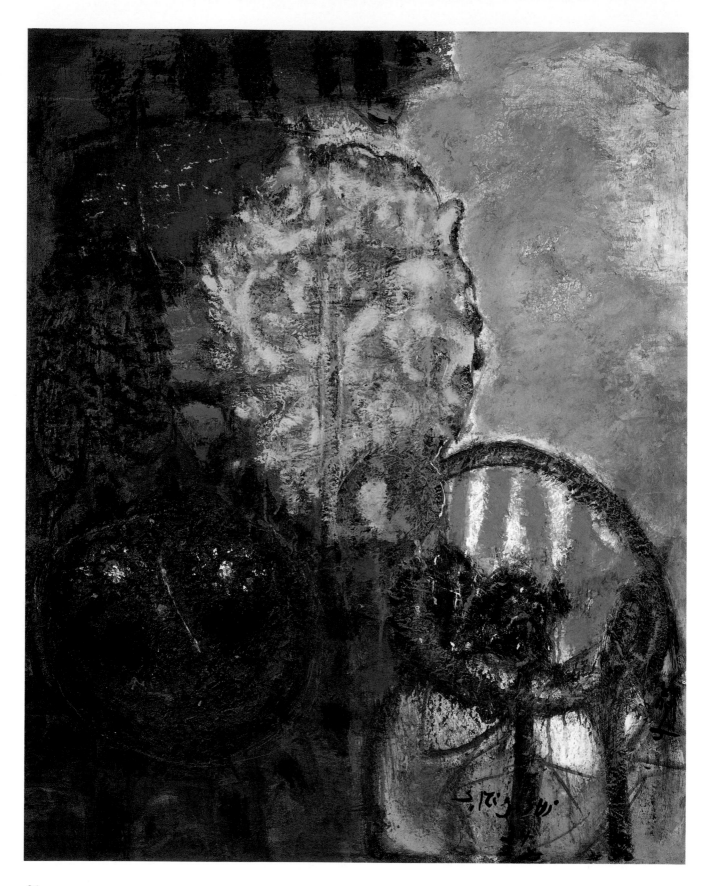

31.
太陽讃歌（山はくれない）
Paean to the Sun
1969

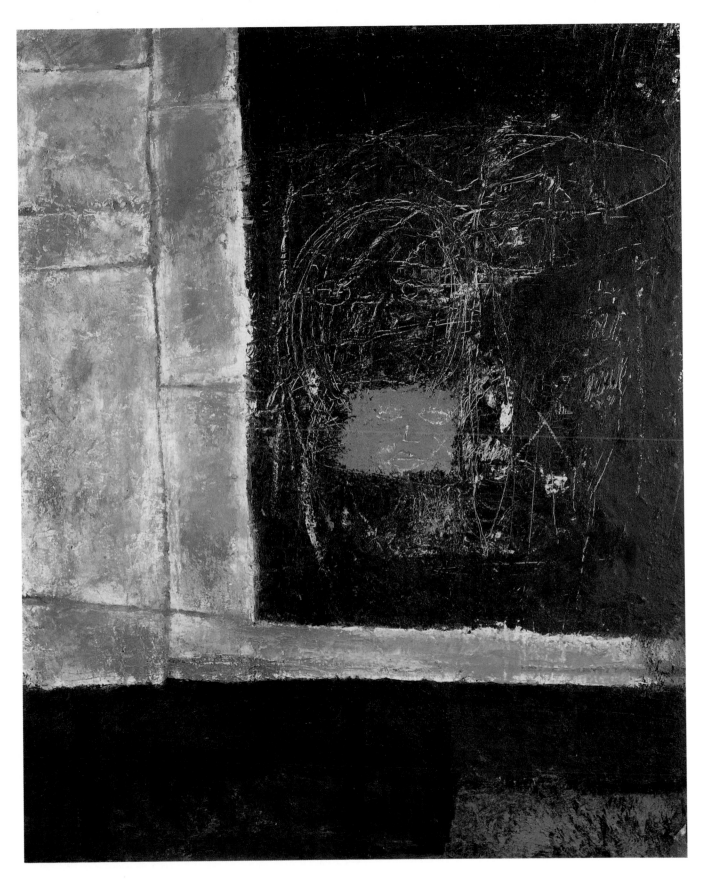

36.
らくがき
Wall with Graffiti
1973

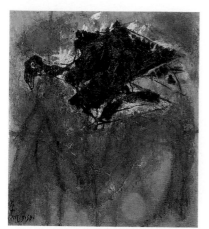

Fig. 10. *Flying Bird on Fire Mountain* 1960

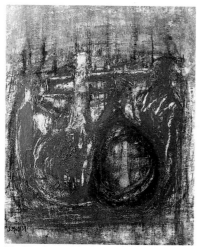

Pl. 23. *Pots with Cross* 1962

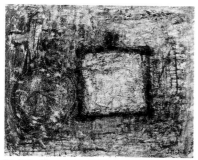

Pl. 24. *Two Pots* 1962

were repeatedly scrapped off and repainted. The result was a texture suggesting the rough surface of pottery that seemed to have been painted with impulsive brushstrokes. The effect was that of a naked scar. Occasionally, the birds recall Braque's. "During that period, I concentrated on abstraction to an extreme extent," Migishi reminisces. This characteristic, which merits the term *iconic*, is also clearly apparent in her 1962 still lifes, *Pots with Cross* (Jūjika no tsubo) and *Two Pots* (Futatsu no tsubo). Both works attest to the enormous change in Migishi's art that had been utterly unforeseeable prior to her trip to France.

In the spring of 1964 Migishi built a house on a hillside in Daikanyama, a section of Higashi Koiso in the town of Ōiso in Kanagawa, where she lived alone. "The southern side of the house looks out over the Pacific Ocean, and on clear days, the island of Ōshima fills the horizon," she writes. "To the left and right, the gentle hills curve down toward the sea." She described her feelings about moving to her new atelier thus:

> From where I sit in the studio, I can see the scenery in three directions. It was here that I began my career as a landscape artist. Two-thirds of the landscape is taken up by the sky. The beauty of the morning and evening sunlight is indescribable, as I wait for the color of the clouds. The landscape is so clear that it seems to sparkle. I get up around dawn and go out into the garden, where I raise all my own vegetables. I grow flowers. Weeding is a major task here.
> It was here that I finally was able to find peace. I am already sixty. I would like to spend the rest of my days as a solitary farmer.

Her work, which indeed reflects the change in her environment, takes on an even freer more rustic quality. The space expands, as the artist's gaze focuses upon the sun, roams through the heavens with the birds, and follows the movement of the clouds. The sharp primary colors add to the fierce intensity of the group of paintings titled *Flying Birds on Fire Mountain* (Hi no yama nite tobu tori), which seem to be painted impulsively. The paintings extol primordial life and the sun, the source of life. *Two Suns*, 1967 (Futatsu no taiyō) depicts the sun and a Mexican ornament of clay shaped like the sun, which Migishi bought at an exhibition in Mexico. In another painting, *Egyptian Falcon*, the sculpture of an ancient Egyptian falcon and the sun are placed near a window. All these motifs symbolize a yearning for the vitality of primitive art and a resistance to the sterility of the modern world, "Where," says Migishi, "people seek art for art's sake, forgetting man's own existence."

In the late 1960s the painting of flowers, a subject Migishi had continued to produce for years, deepened into something more than a mere specialty. A 1965 essay titled "More Flowerlike than Flowers" (Hana yori hana rashiku) describes the process by which she produced these flower paintings: "I kept destroying the paintings in which the materials and color had gradually matured", writes Migishi. "Freedom. A greater sense of space. More suppleness. I kept heartlessly and mercilessly destroying each painting. Boldly and resolutely. This destruction

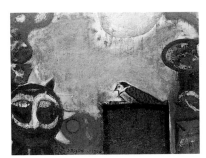

Fig. 11. *Two Suns* 1967

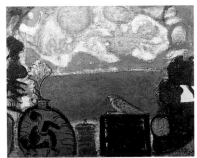

Pl. 29. *Egyptian Falcon* 1967

is repeated over and over to fix the flower on the canvas, to breathe life into it, and to impart brightness, quietness, weight, and depth. I will continue this process until I am satisfied to a degree that I myself call foolish self-torment. This is the most important activity that goes into determining how a painting turns out."

After effecting this major transformation, the sixty-three-year-old Migishi left her splendid Ōiso home at the end of 1968 and moved to the town of Cagnes-sur-Mer on the Mediterranean coast in southern France. She did so, she said, "to cure the chronic gout that her son Kōtarō suffered from and to add vigor to her old age." The time of fruition had finally come for Migishi, who had written the following, perhaps in the 1950s:

> In my view there are two kinds of artists. One type, such as Bonnard, produces a substantial body of work, little by little after the age of sixty; the other type consists of geniuses who burn themselves out in their twenties. . . . A long life is needed to produce large-scale, ambitious work.
> Now, however, I think that there are peaks and valleys in an artist's life. Although there may be violent winds and snow, endurance and a life spent moving ahead and developing as a person are important. One must persevere. I believe that the most important thing, the greatest happiness, for an artist concerns the question of how to lead a full spiritual life as an artist.

Surrounded by the scenery of southern France, with its rich, vibrant colors, Migishi poured her energy into landscape paintings, for which she had begun to develop a keen ambition in Ōiso. The scenery in Venice, especially, delighted her. She writes:

> White Spanish houses, Moroccan villages, too, are interesting. So is the flood of primary colors in southern France. The coastal road in Nice, red stairs in Cagnes-sur-Mer, Vence: there is no lack of subjects to paint. But nothing surpasses Venice. What is the magical enticement that holds me prisoner when I go to Venice from southern France, which is full of dazzling colors? . . . Maybe it is due to the magnificent old buildings lining the shores of the city of canals. Or the romantic aura of the civilization from the Middle Ages that pervades the place. What does this darkness created in the islands on the Adriatic Sea signify? What is the source of the shadows? Traveling from bridge to bridge. Riding in gondolas. Following narrow lanes. Churches. Metal craftsmen. Glassblowing workshops. Striking up an acquintance with woodcarvers. . . . I have visited Venice over and over from autumn and spring.

In 1974 Migishi held a well-received exhibition titled *Flowers and Venice* (Hana to Venechia) in Tokyo and other Japanese cities, featuring the landscapes she had produced in the city of canals. She did not depict the palaces and

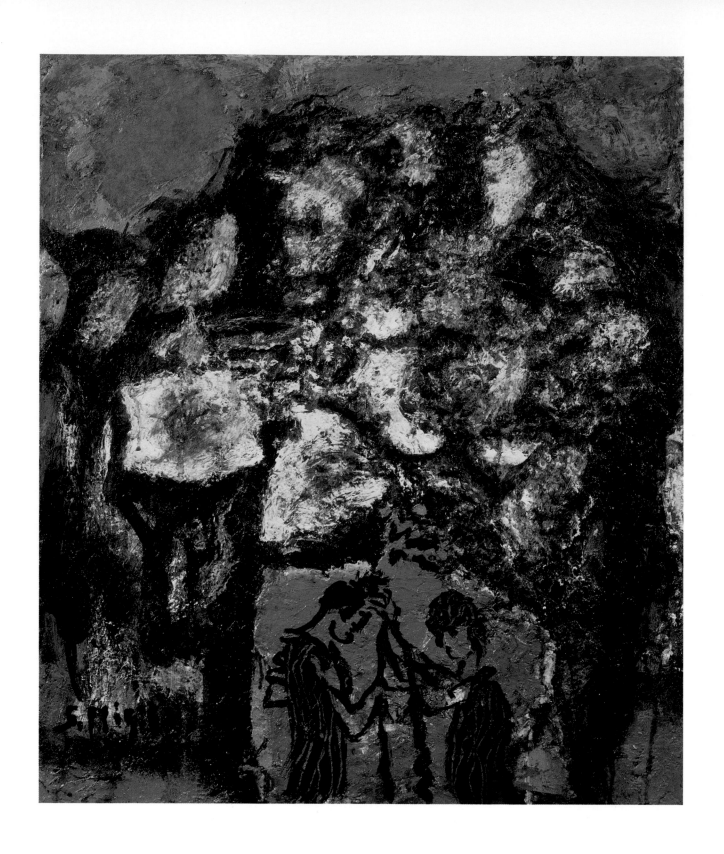

48.
花
Flowers
1976

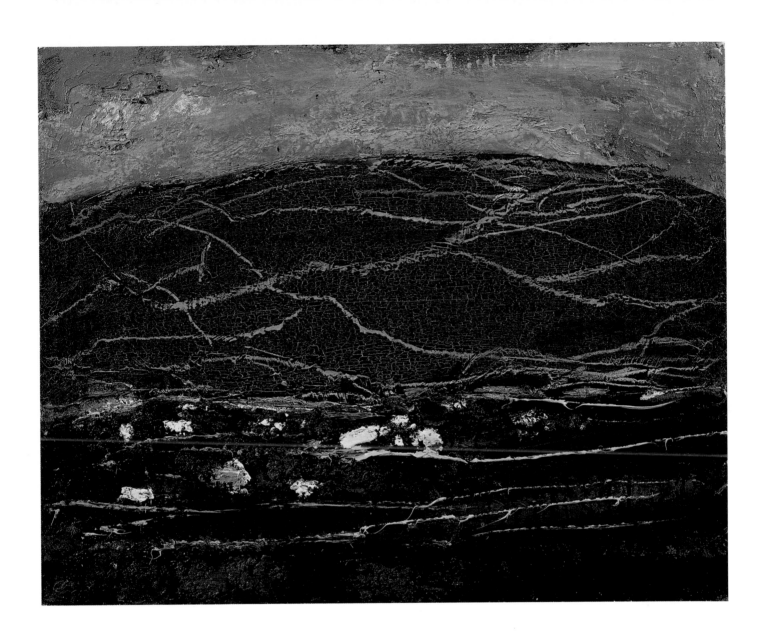

53.
赤い土
Red Earth
1979

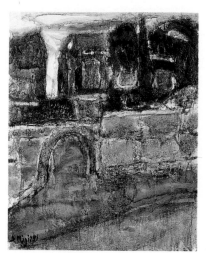

Pl. 39. *Artist's House, Venice* 1973

Fig. 12. *Dawn Moon* 1973

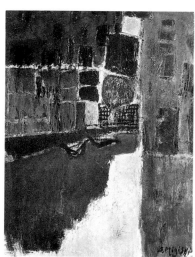

Pl. 42. *Houses on a Small Canal* 1973

churches or the splendor of the Grand Canal, subjects chosen by the 18th-century veduta painters, such as Antonio Canaletto and Francesco Guardi and, later, by Monet. Instead, she depicted scenes of small, little-frequented canals plied by gondolas. The absence of flashy elements infuses the paintings with a deep lyricism, producing quiet overtones and a mellow flavor. In the catalogue prepared for the exhibition, Migishi wrote, "Rocks and walls of this sort are not found in Japan. I was enthralled by this material, on which the changes experienced by innumerable ages and generations of human beings are imprinted without any distortion, as if on a negative. I want to express the intimations, namely, the invisible life that only a sensitive soul can detect." Indeed, at the heart of the profound, freely expressed bravura expressed in works such as *Artist's House, Venice* (Venechia no gaka no ie), *Dawn Moon* (Zangetsu), and *Houses on a Small Canal* (Shōunga no ie), is the dignified existence of this ancient capital, which resembles the lees of a fine liquor that has aged for years. The city's spirit is overlayed by that of the artist, whose depth has been attained by years of perseverance. These spirits breathe and nestle together, as though seeking warmth.

Migishi's Venetian works, which inaugurated a new stage in her life as a landscape painter, were shown in Paris prior to their exhibition in Japan. They were even better received in Paris than she had expected. Emboldened by her success, she abandoned her plans to return to Japan, deciding instead to continue painting in France. In the spring of 1974, she quit Cagnes-sur-Mer, despite its beautiful scenery, because the growing local tourist industry had robbed the area of its tranquillity. She moved into the interior of France, to a small village called Véron on the edge of the Bourgogne region.

A voracious reader since childhood, Migishi possesses a deep literary sensibility. She alludes to the poetry of the T'ang dynasty Chinese poet-painter Wang Wei in the following description of her state of mind after moving to this new locale:

> The gate of my thatched house in Véron is always closed, and I have almost no visitors. . . . All day long I am completely engrossed in the work I am painting. Whether sleeping or awake, I cannot get away from the painting. I lead a completely unimpeded existence, except that I occasionally suffer from sudden spasms, a chronic problem. How many years have lapsed, I wonder? The passage of more than a decade is but a dream. I ask myself what draws me to this out-of-the way spot. I just want to live in peace. That is all.

In fact, Migishi's paintings following her move to Véron reveal a sort of oriental poetic sensibility. They display conflict characteristic of a person who has cast off the world but still harbors irrepressible passion. The repeated clashes between these two extremes eventually led to Migishi's attainment of a state of resignation.

The clash between two poles, the contrasting forces of light and shadow, of

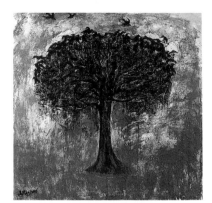
Pl. 49. *Tree in Bourgogne* 1978

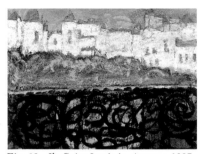
Fig. 13. *Ile Saint-Louis in Autumn* 1987

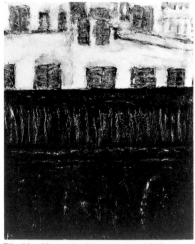
Pl. 62. *House in Montmartre* 1987

violent passion and contemplation, have been constants in Migishi's art since the Karuizawa days. She wrote that the creation of fearless landscapes required "the artist to spend innumerable hours and days inhaling and digesting the nature of the scene; otherwise the true natural features cannot be depicted." As her words attest, she lingered on that isolated horizon and firmly grasped the vast expanse of land, as seen in *Red Earth* (Akai tsuchi). She also quietly listened to the murmuring of the life that dwelt therein, as seen in *Tree in Bourgogne* (Burugōnyu no ippon no ki).

After the 1980 retrospective of her paintings, Migishi kept her Véron atelier, while seeking subjects once more in other European landscapes outside of Bourgogne. Her work displayed a broad range of expressive elements suggesting that a desire to move in a new direction was stirring inside her.

In preparation for the 1985 exhibition at the Okazaki Museum of Art and the Museum of Modern Art, Kamakura, which also traveled to other Japanese cities, she began painting scenes of Paris. In the exhibition catalogue, she wrote, "First, I did Venice, then Bourgogne. This time I have depicted Paris, and now I think I will call it an end. At the age of eighty, I consider this my last study phase." Her words convey a sense of her drive, which had not dimmed, but painting in temperatures that exceeded minus 30 degrees centigrade must have been a terrible ordeal, no matter how "lovely Paris in winter" may have been.

Pastel sketches shown at the exhibition were later turned into oil paintings such as *Ile Saint-Louis in Autumn* (Iru Sanrui no aki) and *House in Montmartre* (Monmarutoru no ie). These paintings capture the beauty of Paris. In their depths lies a feminine grace. The works were shown at the exhibition Migishi held in 1989.

Later Migishi headed south once more, visiting the Andalusia region of Spain and Taormina in Sicily. The landscape of the dry Mediterranean world suffused with dazzling light obviously possesses a quality that has made it a second spiritual home for Migishi's art. Her brush flies over the canvas with a cry of delight at this reunion. In the presence of beauty that arouses an involuntary shout of joy, her boundless passion, the very flame of life, triggers an impulse to seek more beauty. In the presence of a veritable feast of dazzling light, it generates a greater wealth of vivid colors.

Migishi returned to Japan in 1989. She recently wrote, however, that she hopes to go to Paris again and take up the only subject she has not yet explored in her Sixty-six-year career as an artist-human beings. It is not clear whether Migishi will choose to set out on a new adventure or remain in comfortable Japanese surroundings. In either case, we may be sure that the brilliant flame of her artistic spirit will continue to burn, undiminished, until the very end. The existence of a woman painter who displays such conviction is a source of pride, a source of hope.

——Curator of The Museum of Modern Art, Kamakura

Translated by Janet Goff

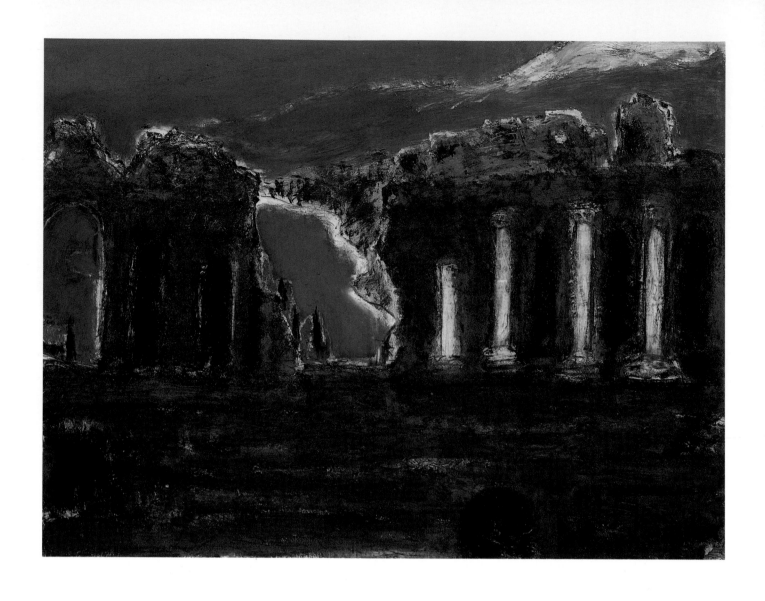

81.
タオルミナ
Taormina
1989

Note

1. The other artists, in order of their ranking, were Zenzaburō Kojima, Yatarō Noguchi, Sōtarō Yasui, Takeshi Hayashi, Setsuko Migishi, Tasushirō Takabatake, Yoshio Mori, Shintarō Suzuki, Keisuke Sugano and Katsuyuki Nabei.

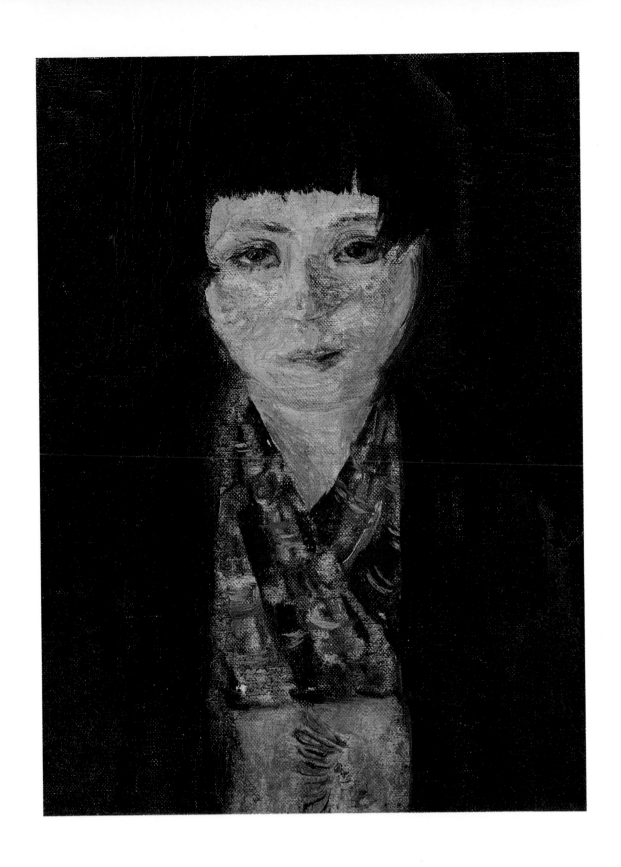

1.
自画像
Self-Portrait
1925

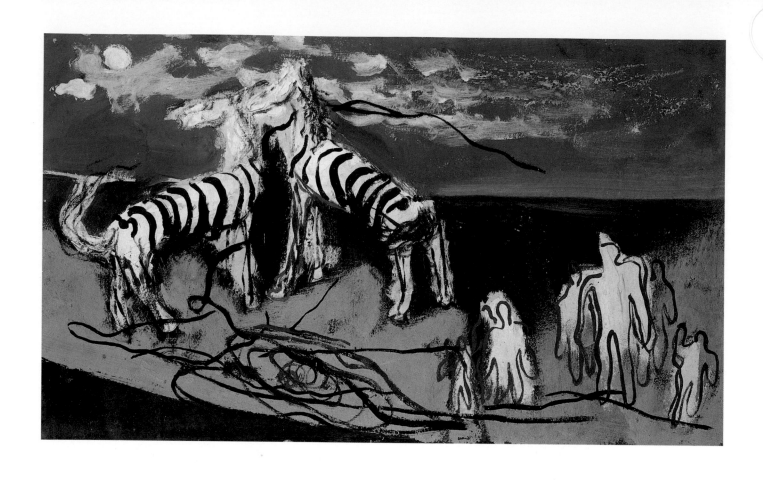

2.
月夜の縞馬
Zebras in the Moonlight
1936

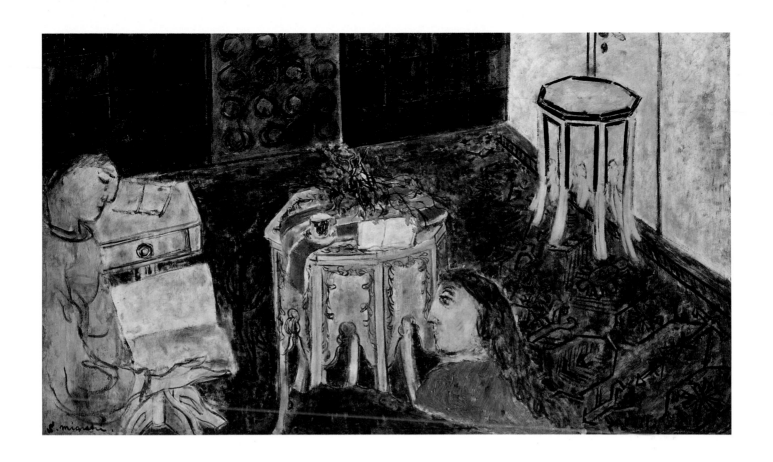

3.
室内
Interior
1936

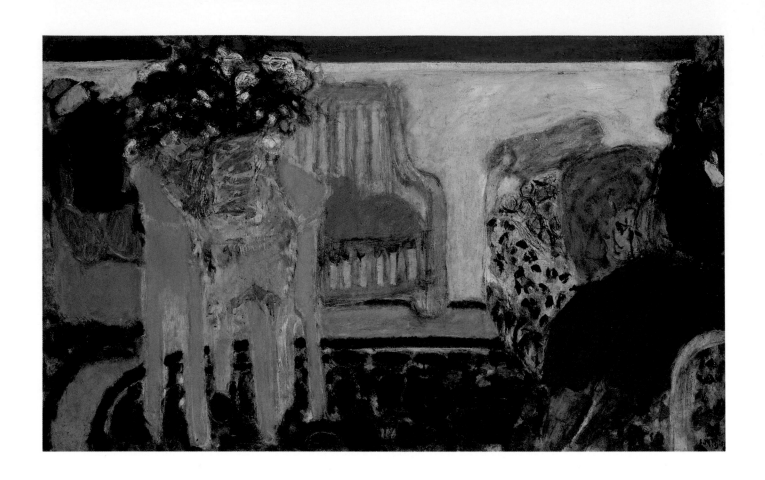

5.
室内
Interior
ca.1940

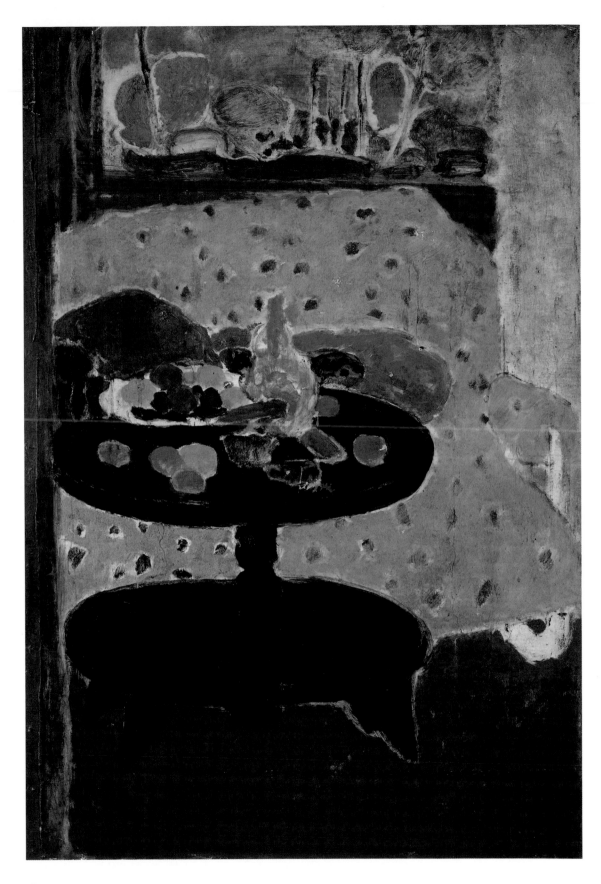

6.
室内
Interior
1942

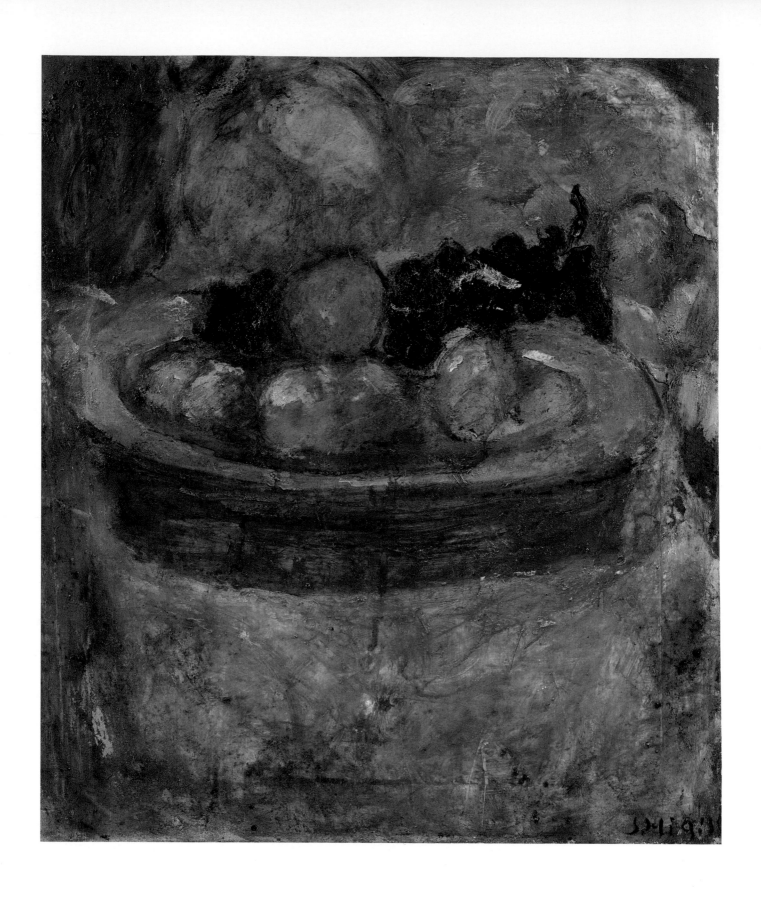

7.
静物
Still Life
1946

8.
静物
Still Life
1948

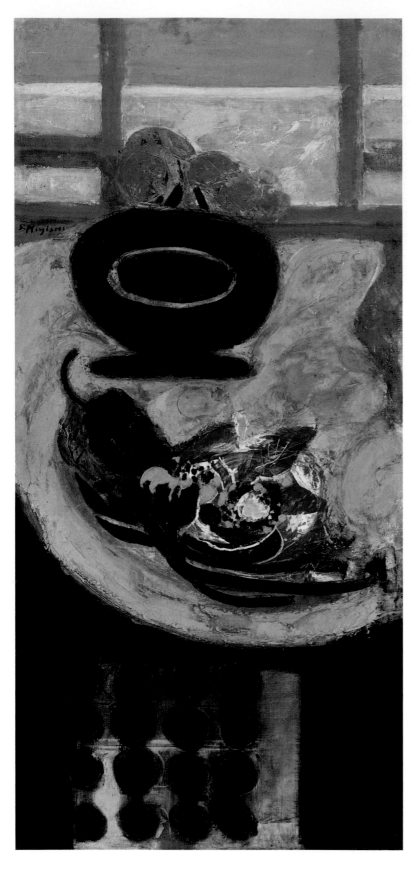

10.
静物（窓）
Still Life in Window
1950

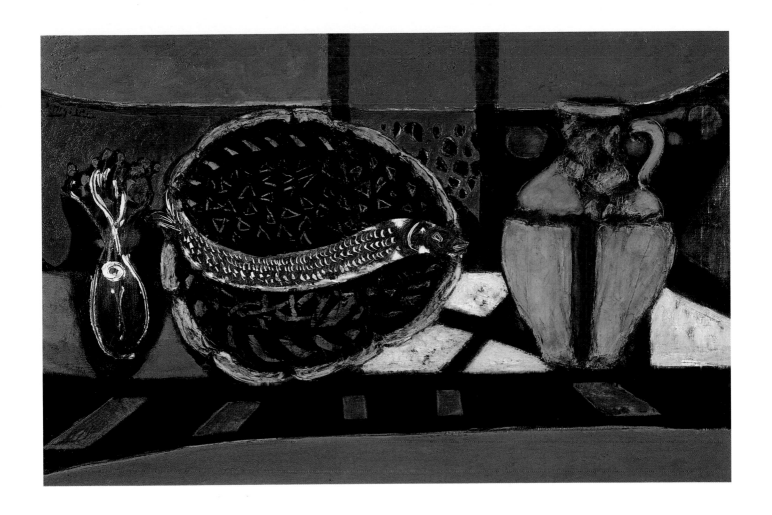

11.
魚とインカの壺
Fish and Incan Pot
1951

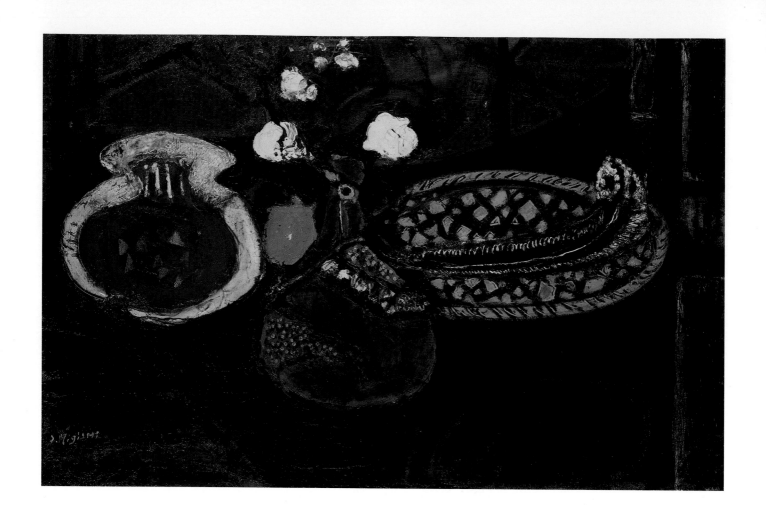

12.
花と魚
Flowers and Fish
1952

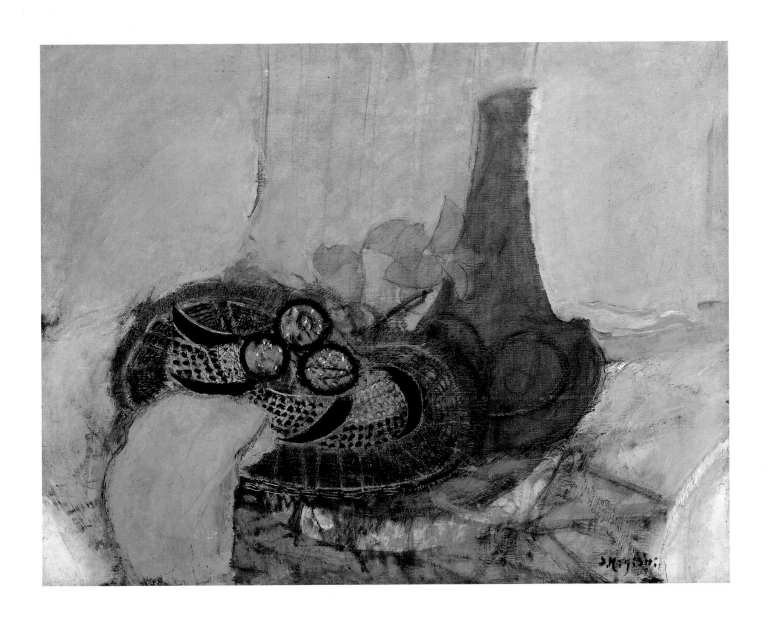

13.
静物
Still Life
1953

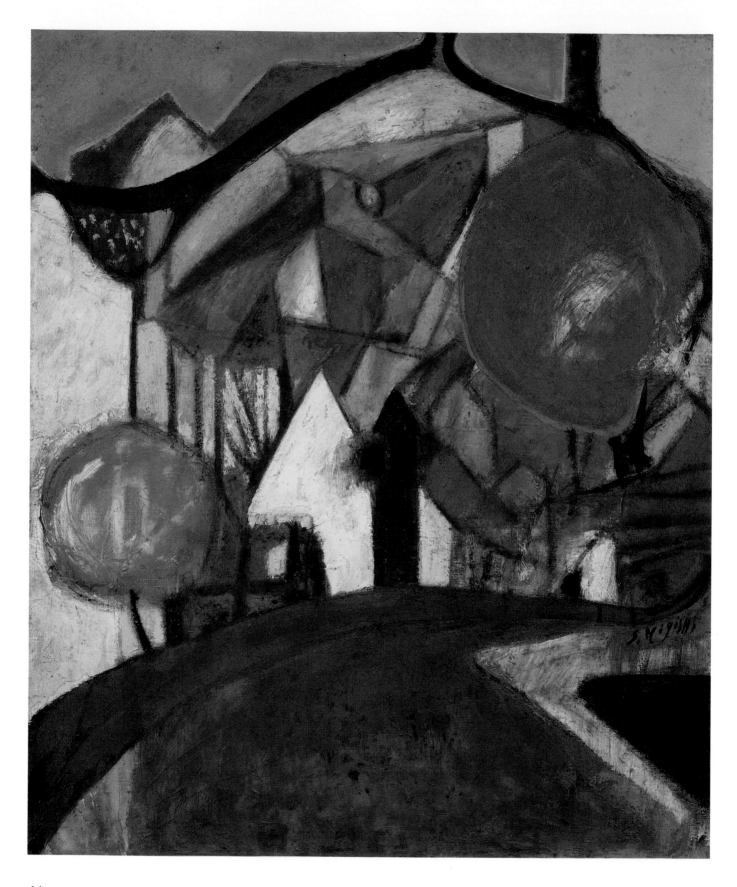

14.
ミモザ咲くヴァロリース
Mimosa Blooming in Vallauris
1954

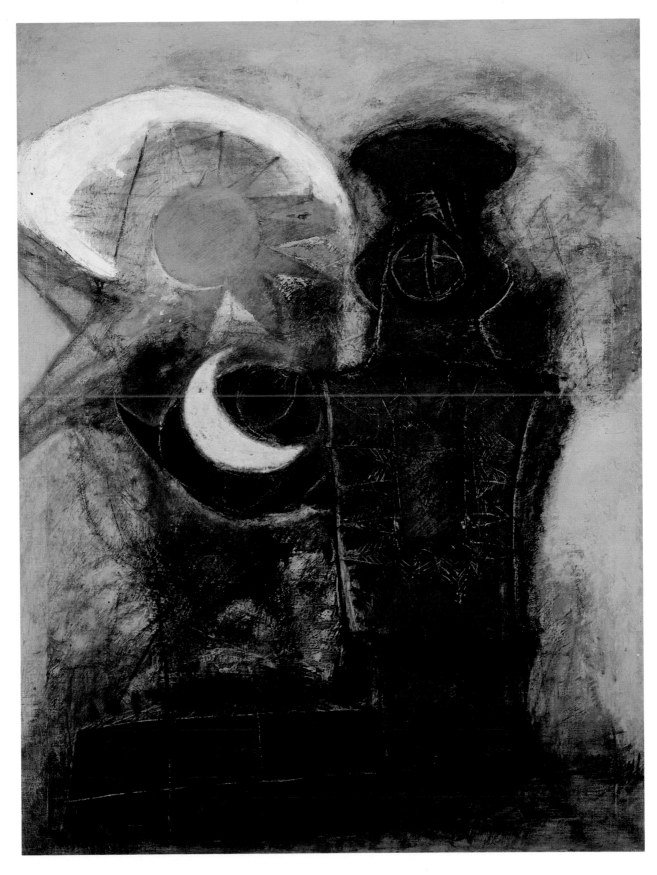

15.
楯を持った武士
Warrior Figurine with Shield
1956

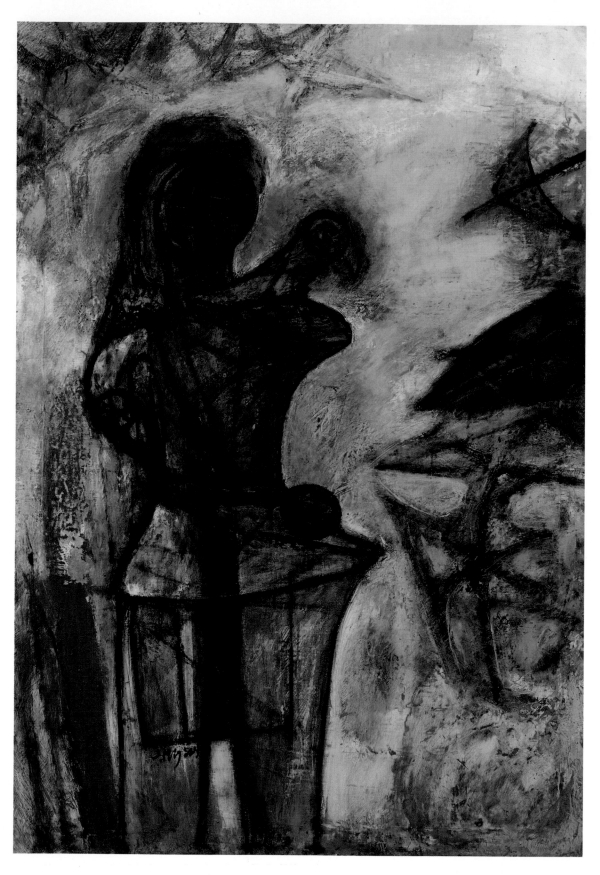

16.
鳥を持った埴輪
Ancient Figurine with Bird
1957

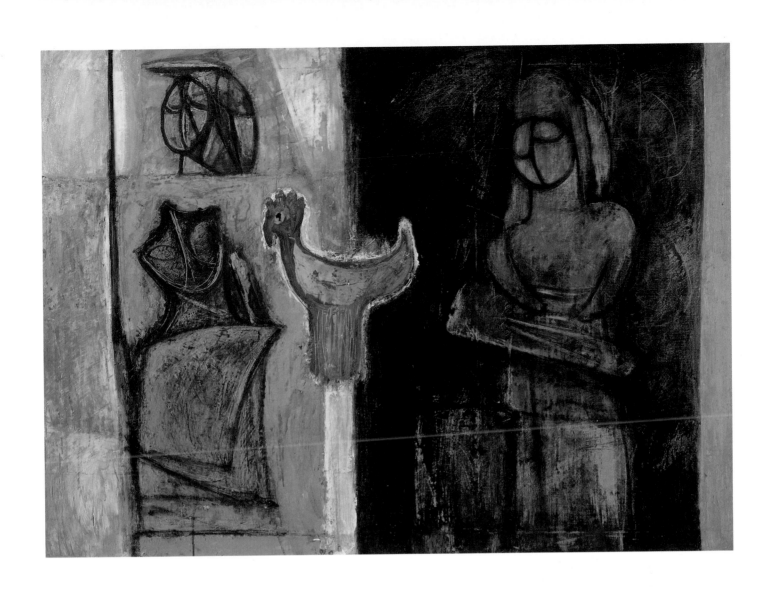

17.
鳥と琴を弾く埴輪
Bird and Ancient Figurine with Zither
1957

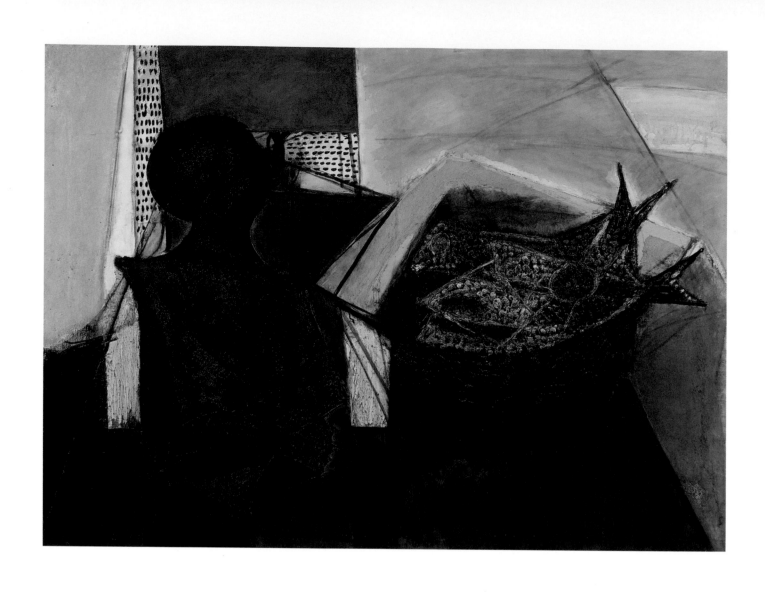

18.
はにわの世界（B）
Ancient Japanese Figurine B
1958

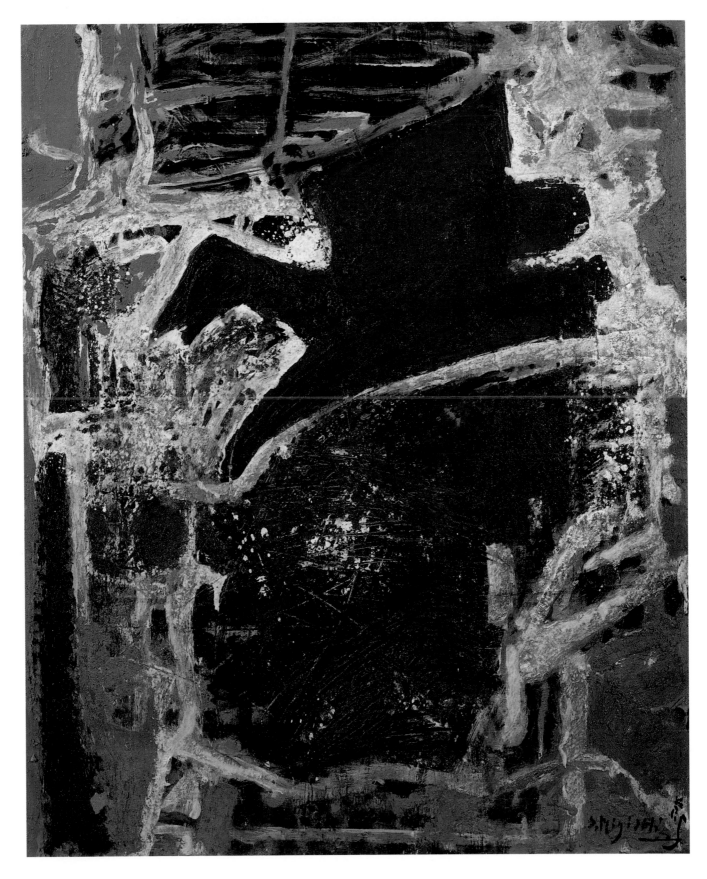

19.
火の山にて飛ぶ鳥
Flying Bird on Fire Mountain
1960

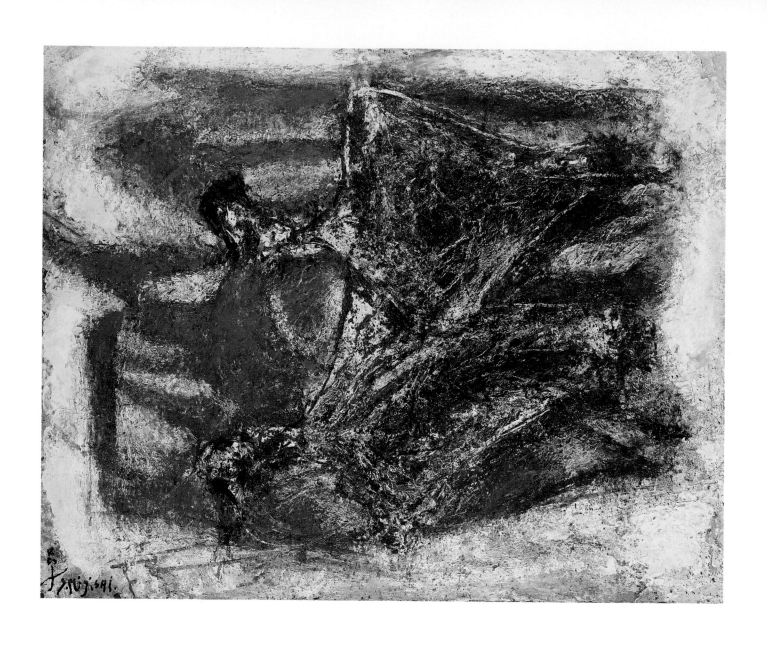

20.
火の山にて飛ぶ鳥
Flying Birds on Fire Mountain
1960

52

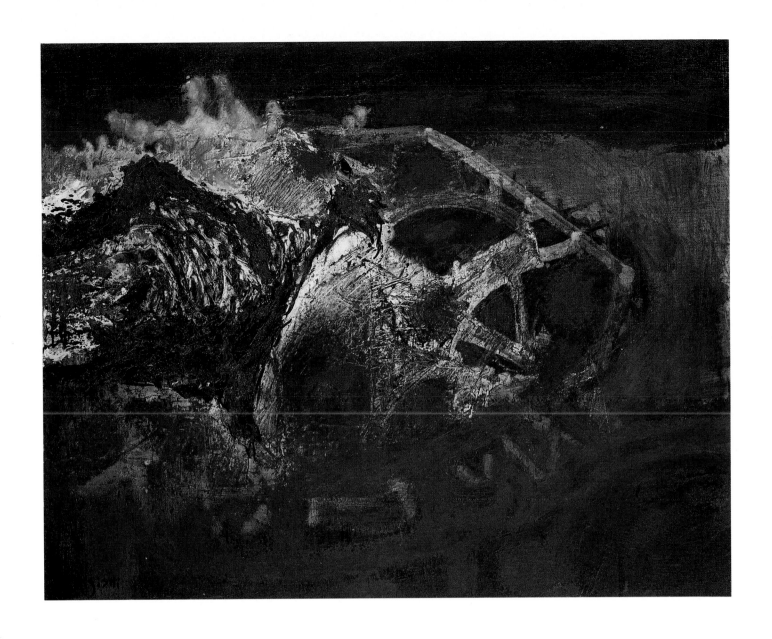

21.
火の山にて飛ぶ鳥
Flying Bird on Fire Mountain
1960

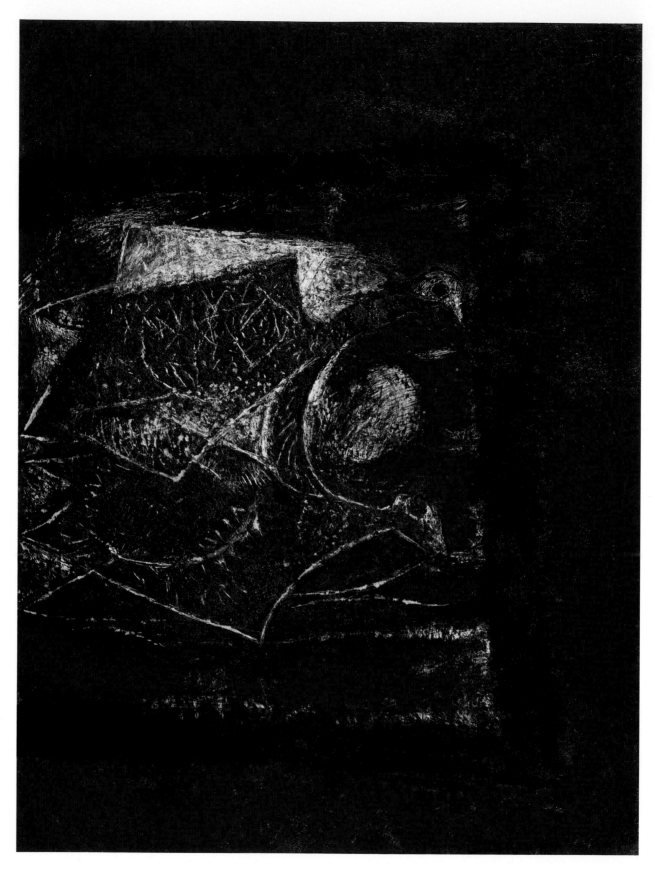

22.
囚
Captured Birds
1960

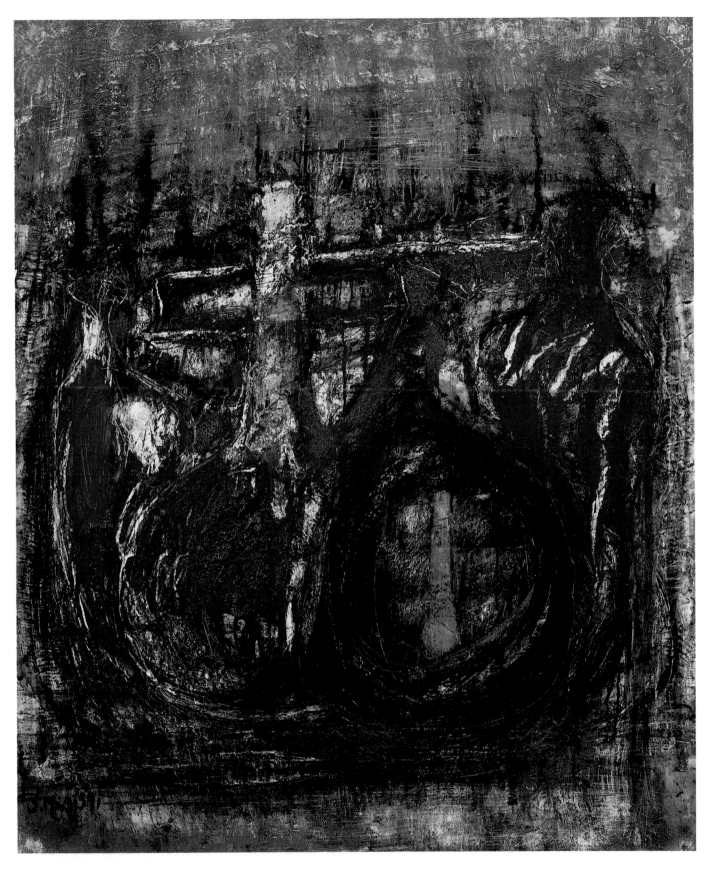

23.
十字架の壺
Pots with Cross
1962

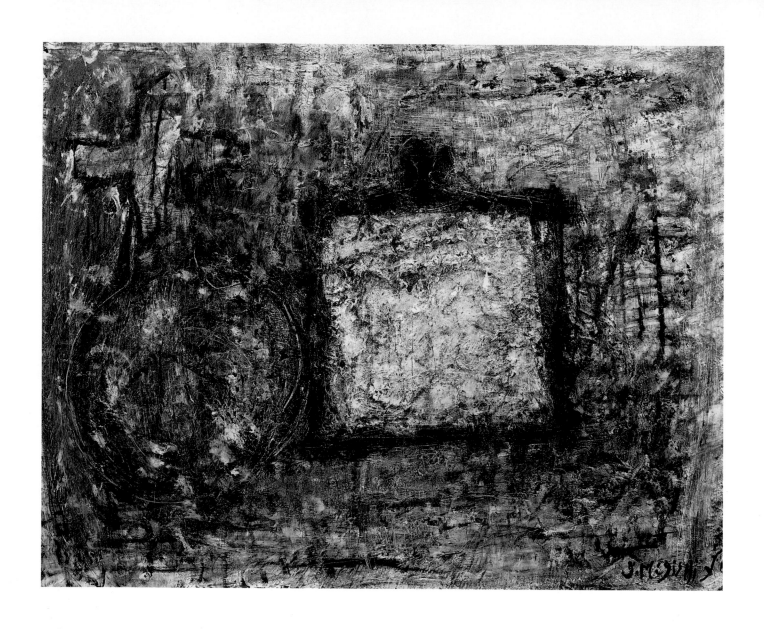

24.
二つの壺
Two Pots
1962

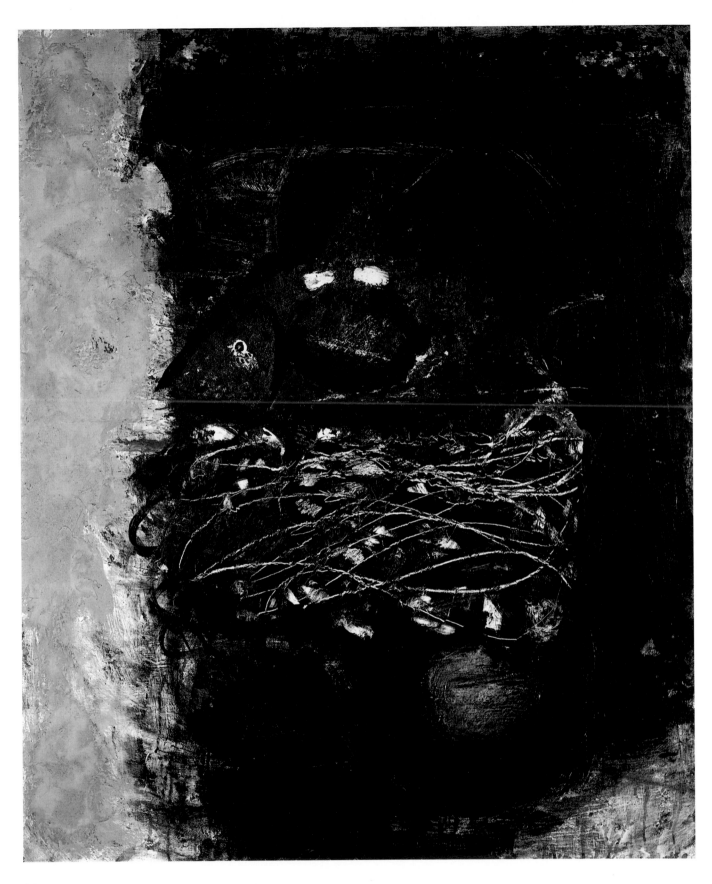

26.
魚のいる静物
Still Life with Fish
1963

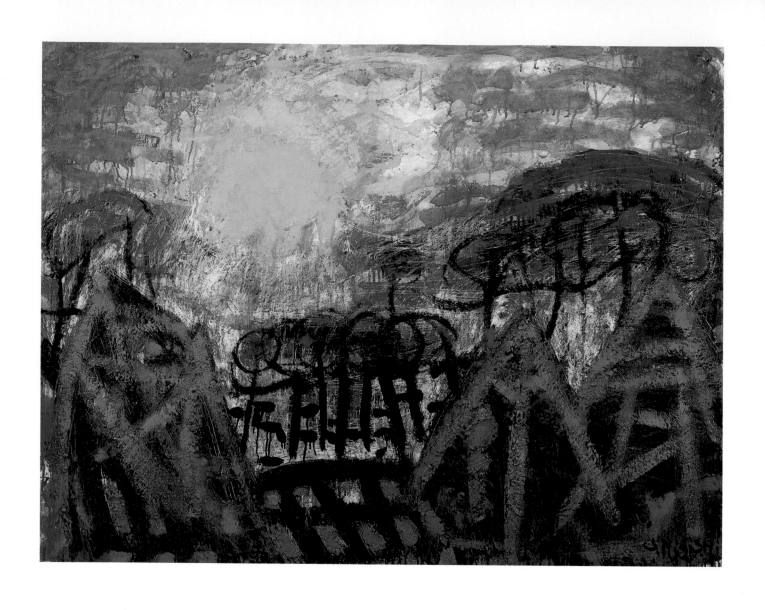

27.
太陽讚（II）
In Praise of the Sun II
1965

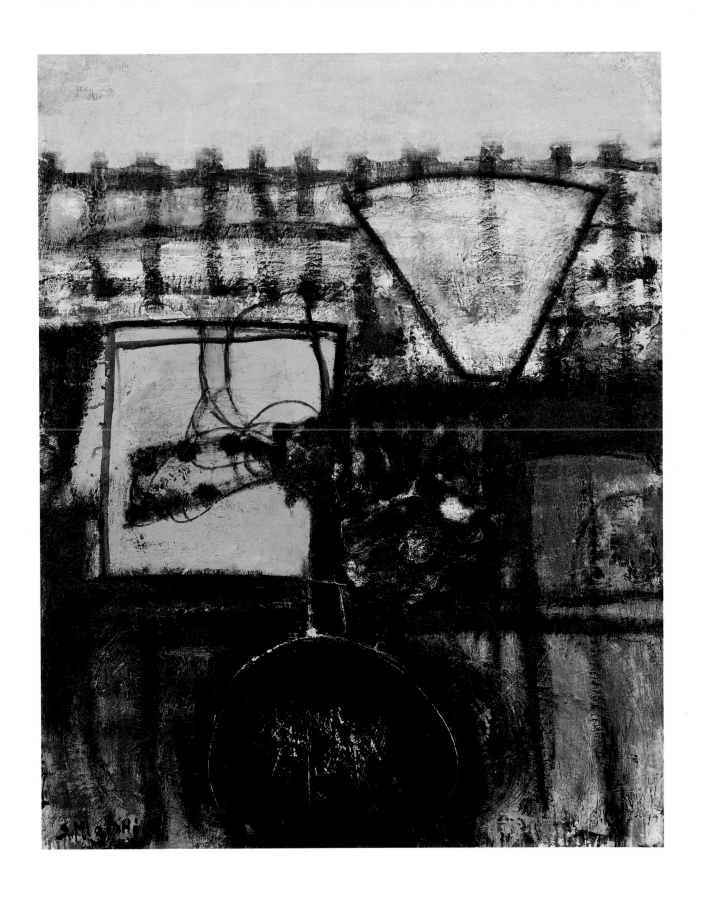

28.
永久花
Flower of Eternity
1967

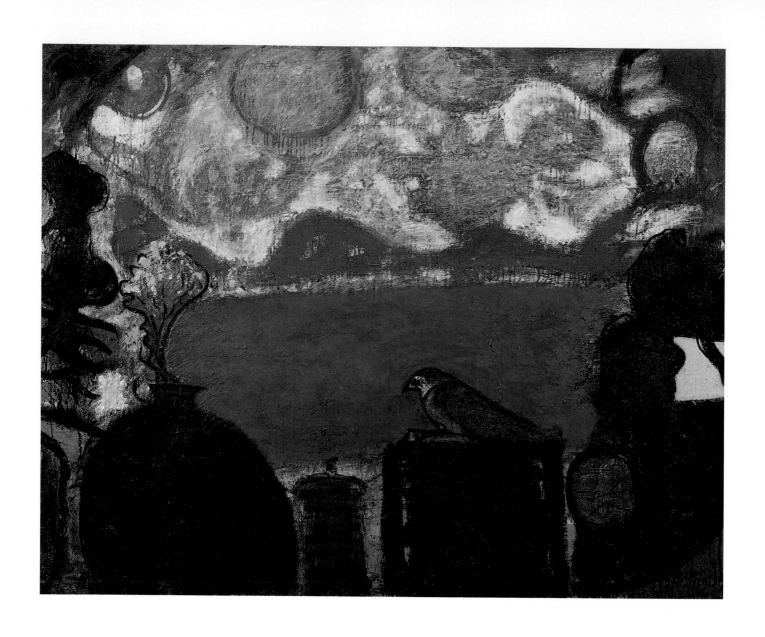

29.
エジプトの鷹
Egyptian Falcon
1967

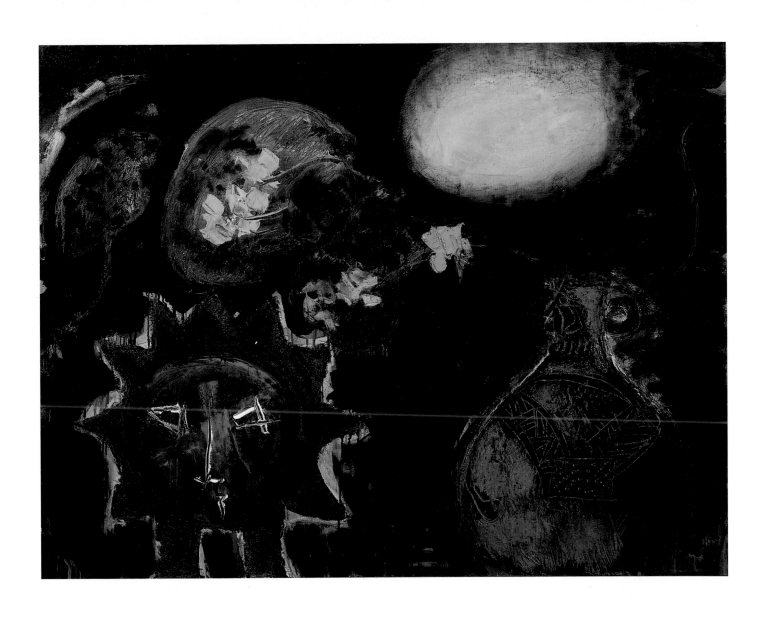

30.
やがて夜が
Approaching Night
1968

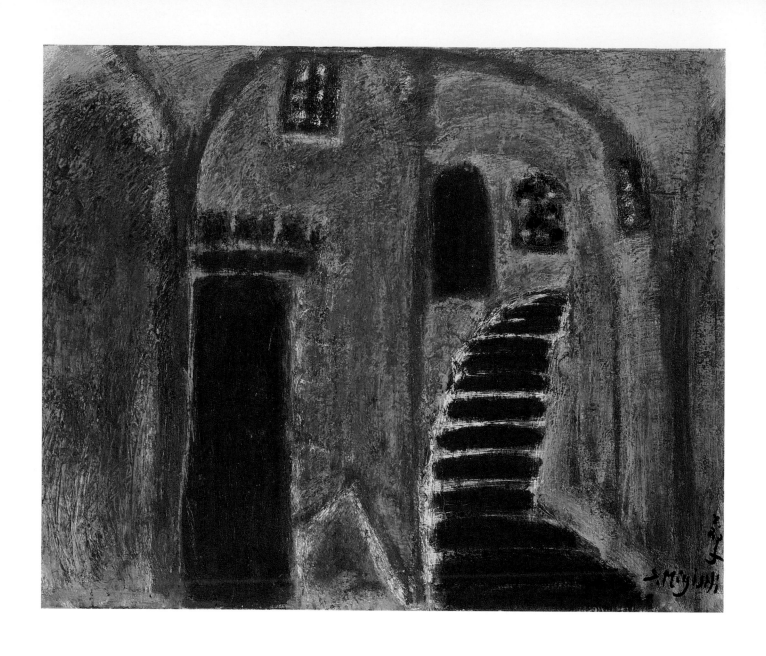

32.
カーニュの家
House in Cagnes-sur-Mer
1969

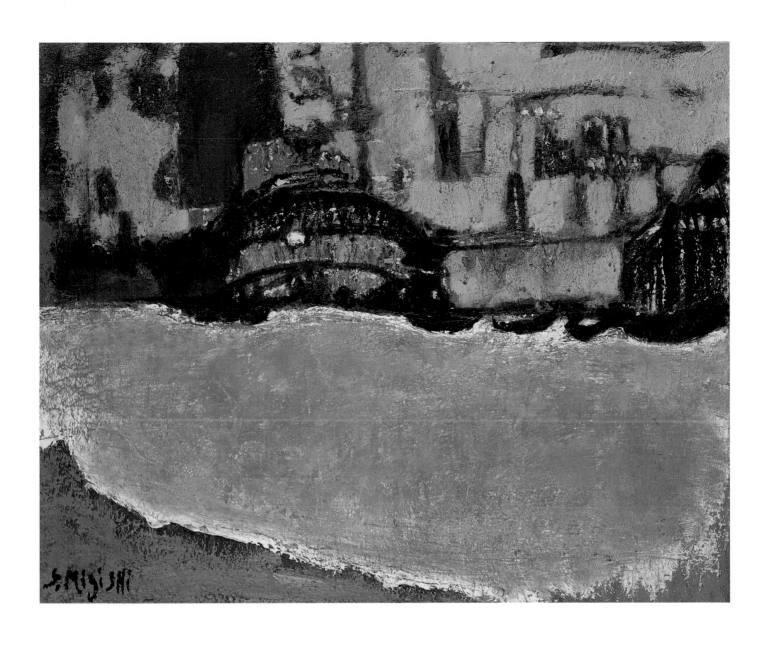

33.
桃色の家
Pink Houses
1971

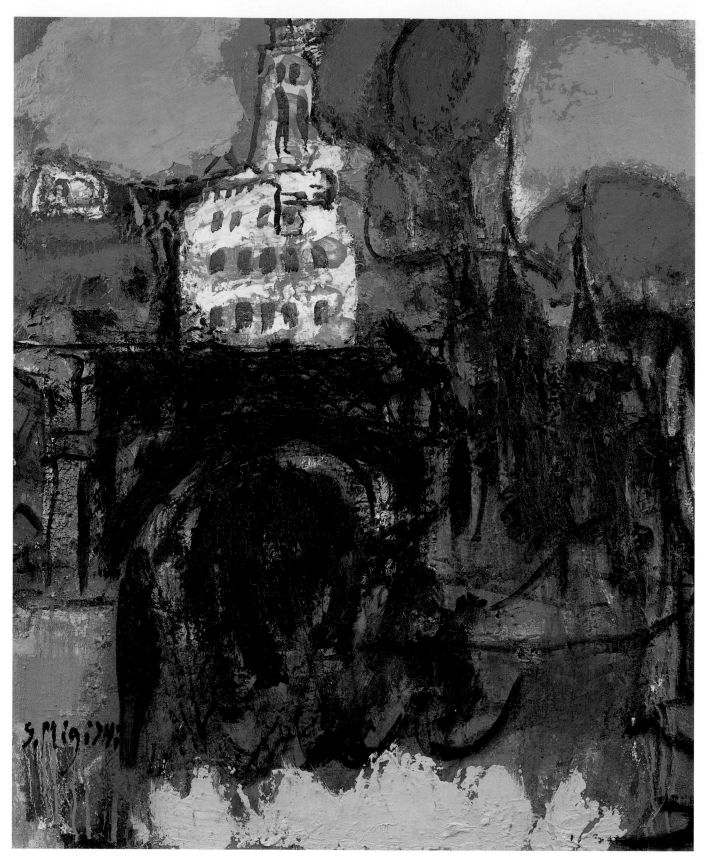

34.
橋のヴェネチア
Bridge in Venice
1971

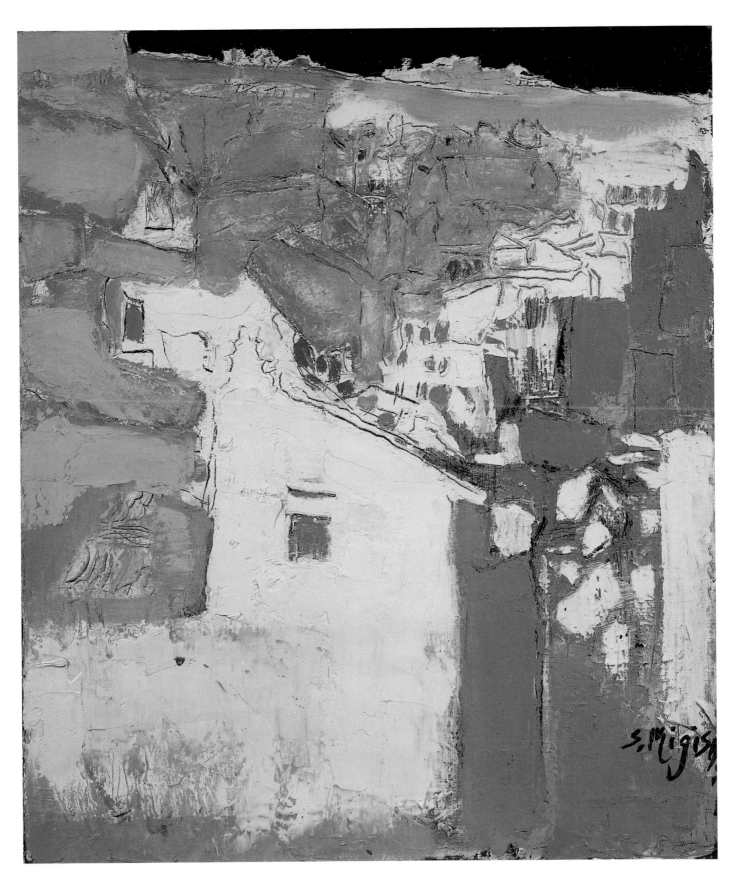

35.
スペインの白い町
White Town in Spain
1972

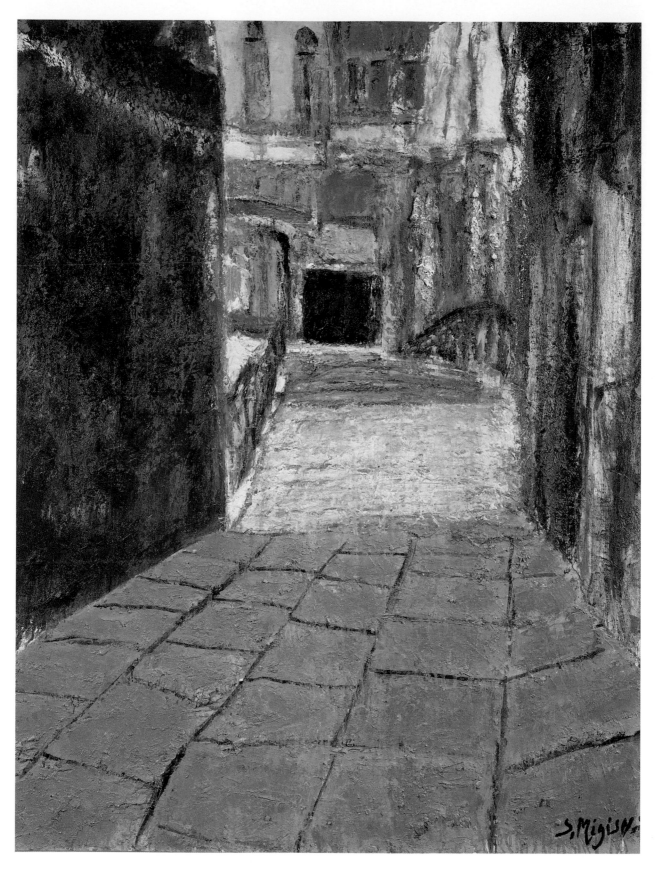

37.
石だたみ
Stone Pavement
1973

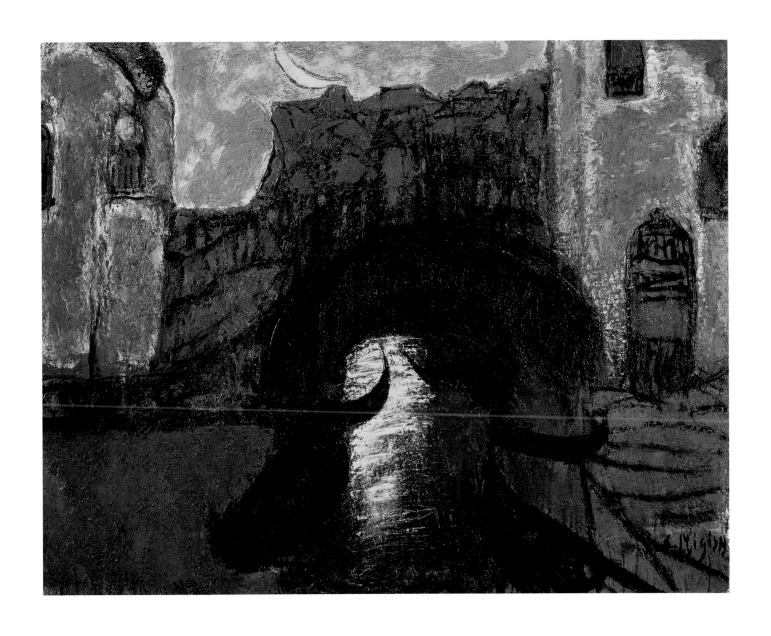

38.
下弦の月
Waning Moon
1973

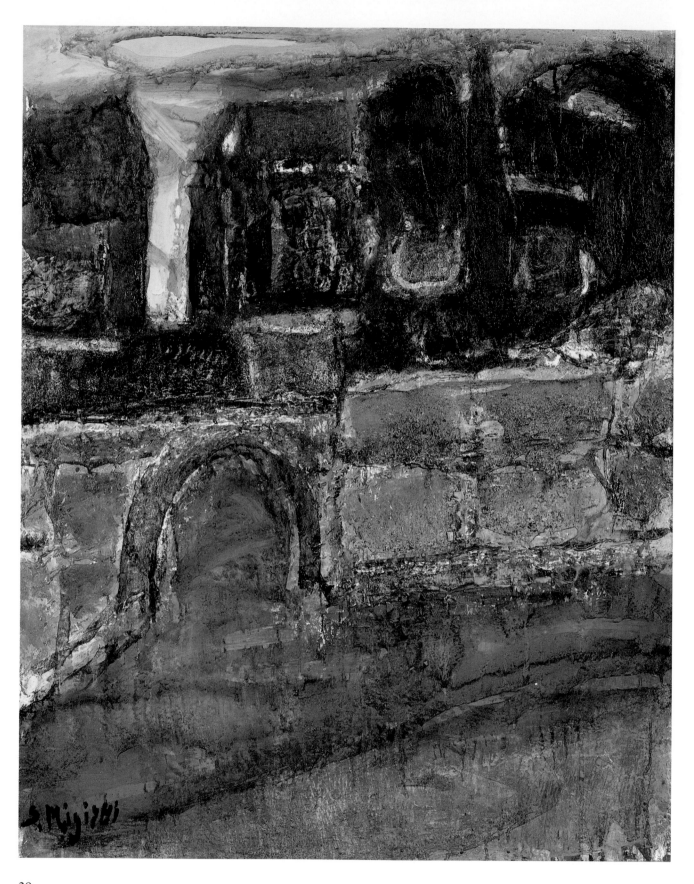

39.
ヴェネチアの画家の家
Artist's House, Venice
1973

40.
ヴェネチアの家
Houses in Venice
1973

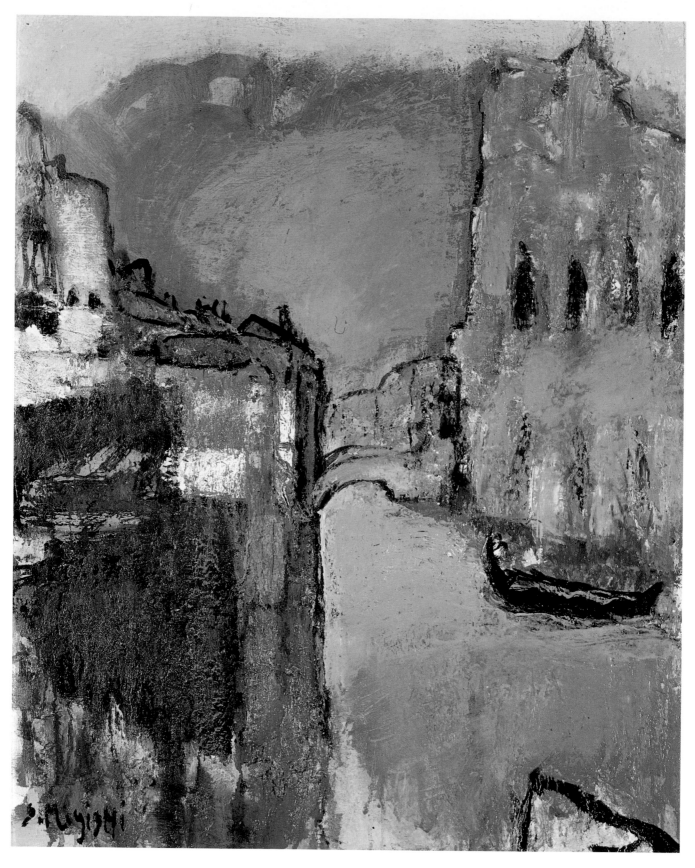

41.
霧
Mist
1973

42.
小運河の家
Houses on a Small Canal
1973

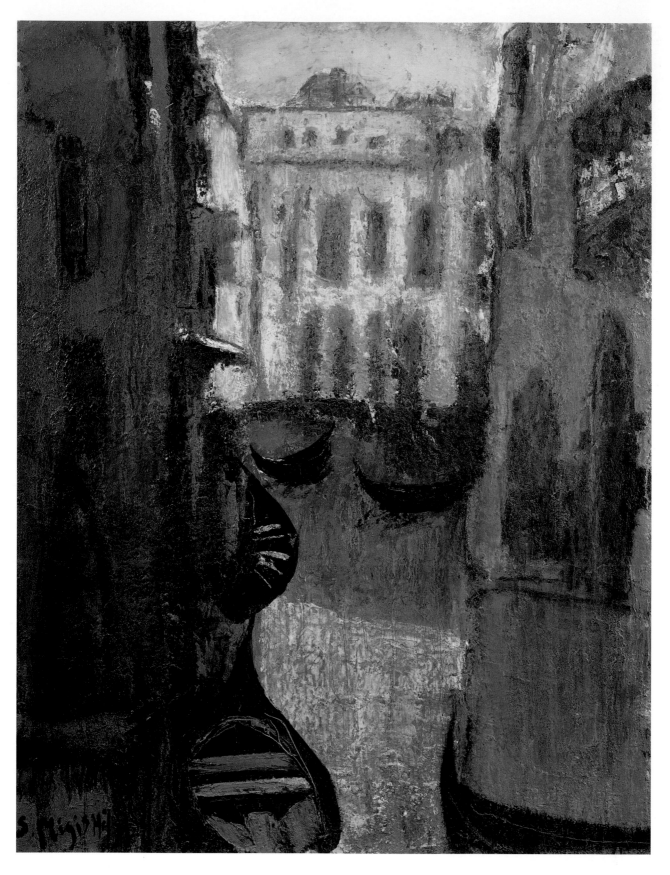

43.
プチカナル
Small Canal
1973

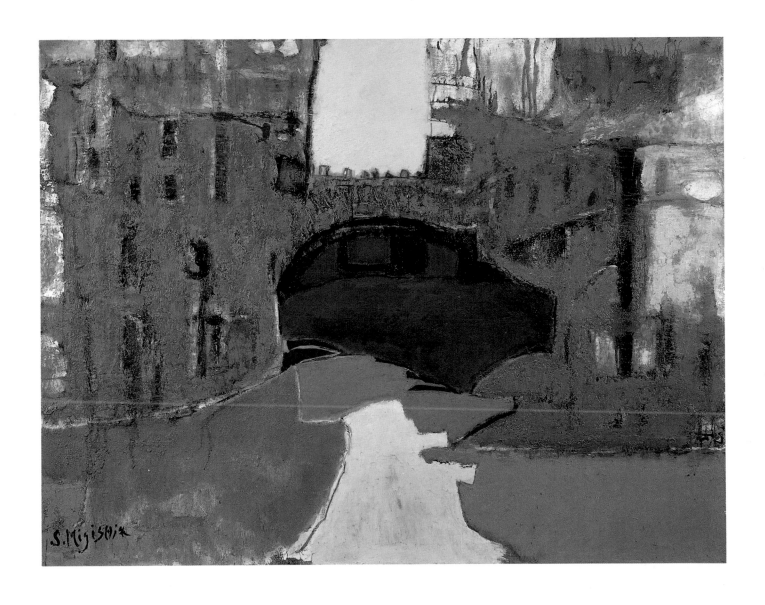

44.
ヴェネチア
Venice
1973

45.
花（3）
Flowers Ⅲ
1973

46.
花 (10)
Flowers X
1974

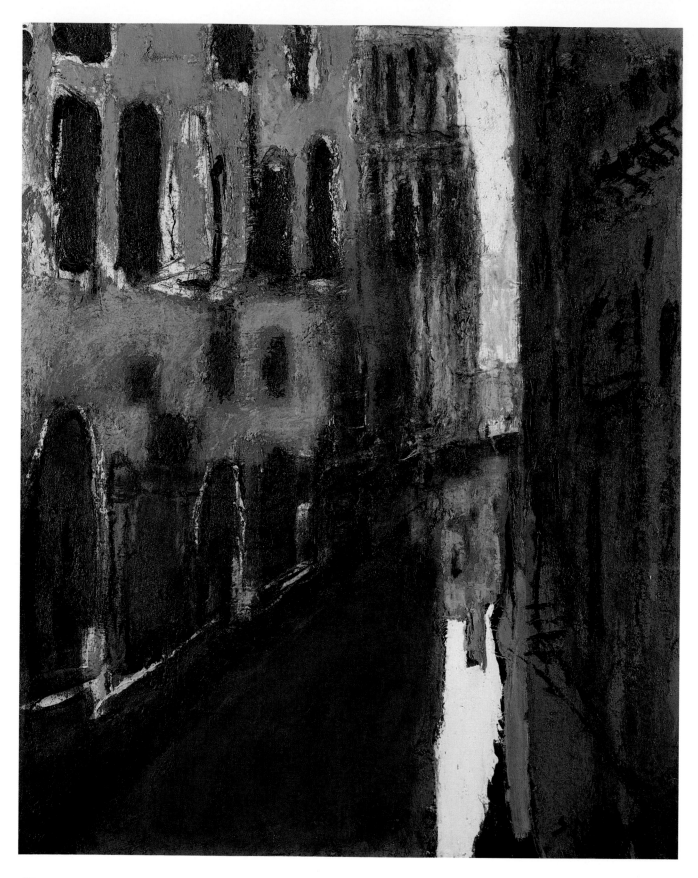

47.
細い運河
Narrow Canal
1974

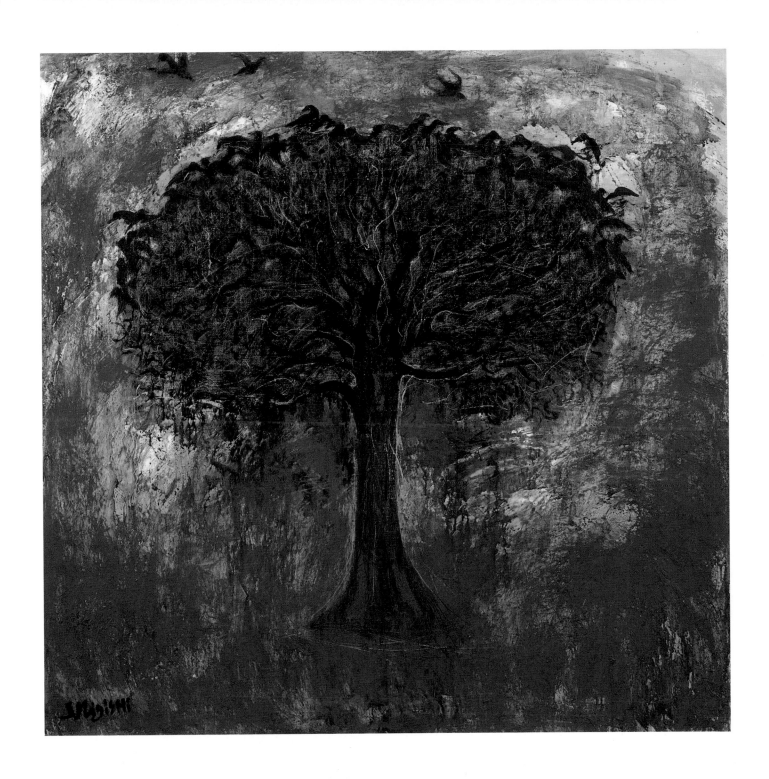

49.
ブルゴーニュの一本の木
Tree in Bourgogne
1978

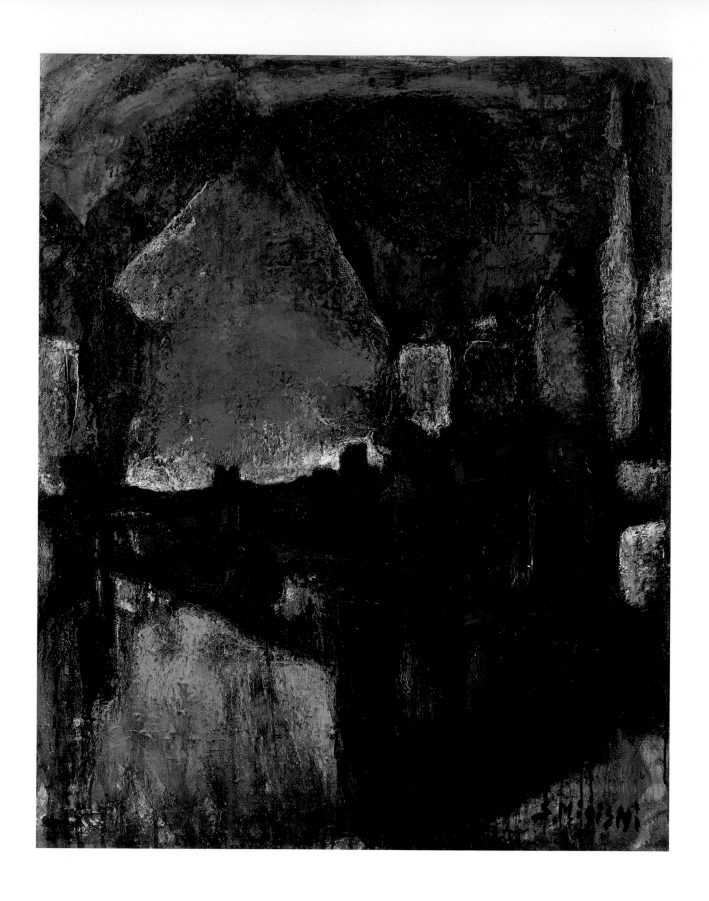

50.
冬のヴェロン
Véron in Winter
1978

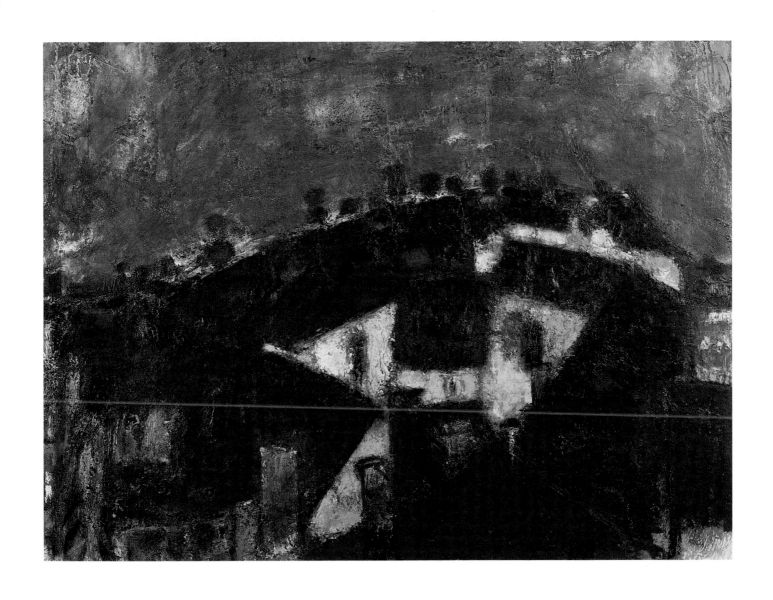

51.
雷が来る
Approaching Thunder
1979

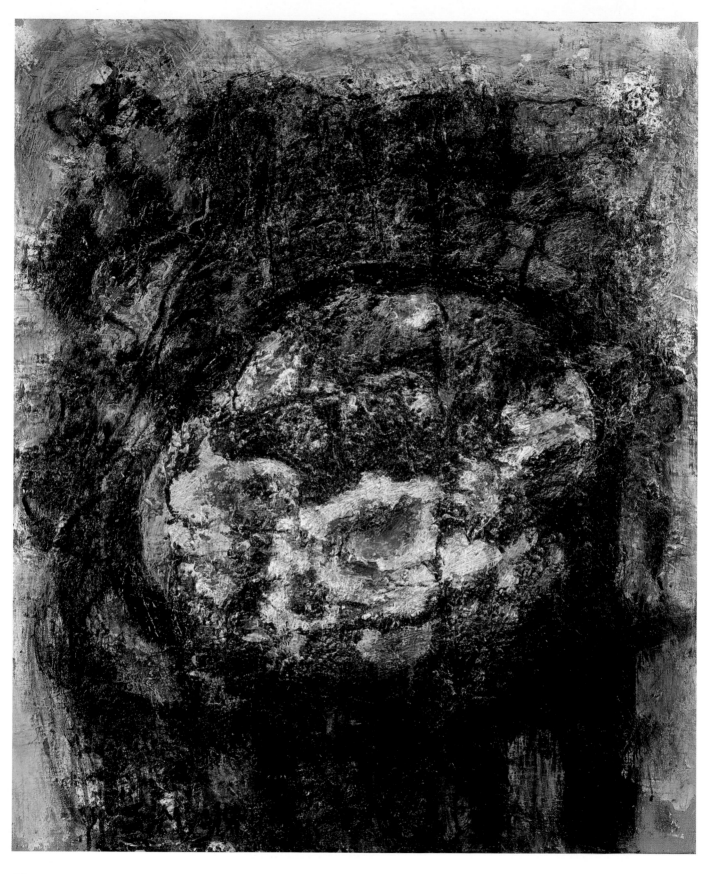

52.
紫の花
Purple Flowers
1979

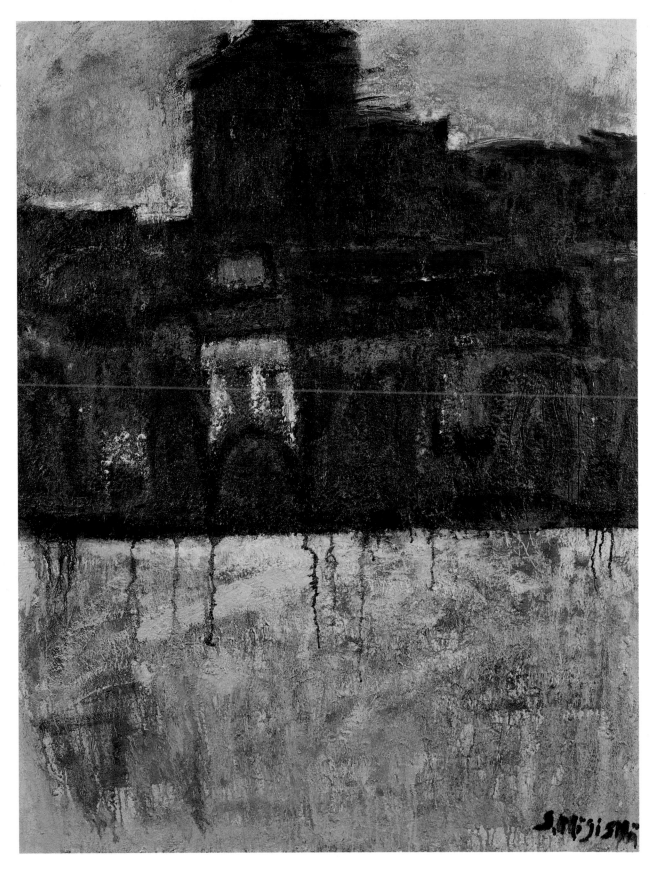

54.
ブルゴーニュの麦畑
Wheat Field in Bourgogne
1979

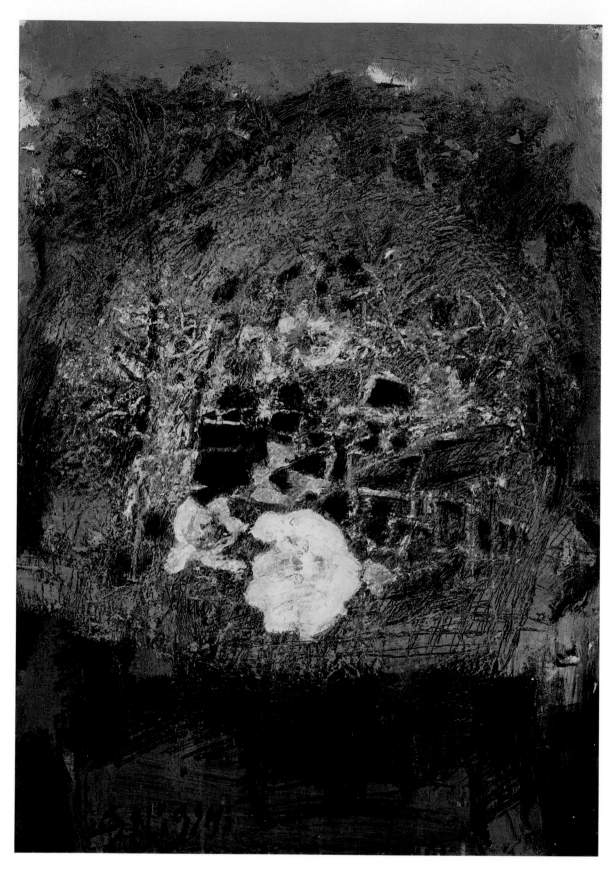

55.
椿
Camellias
1980

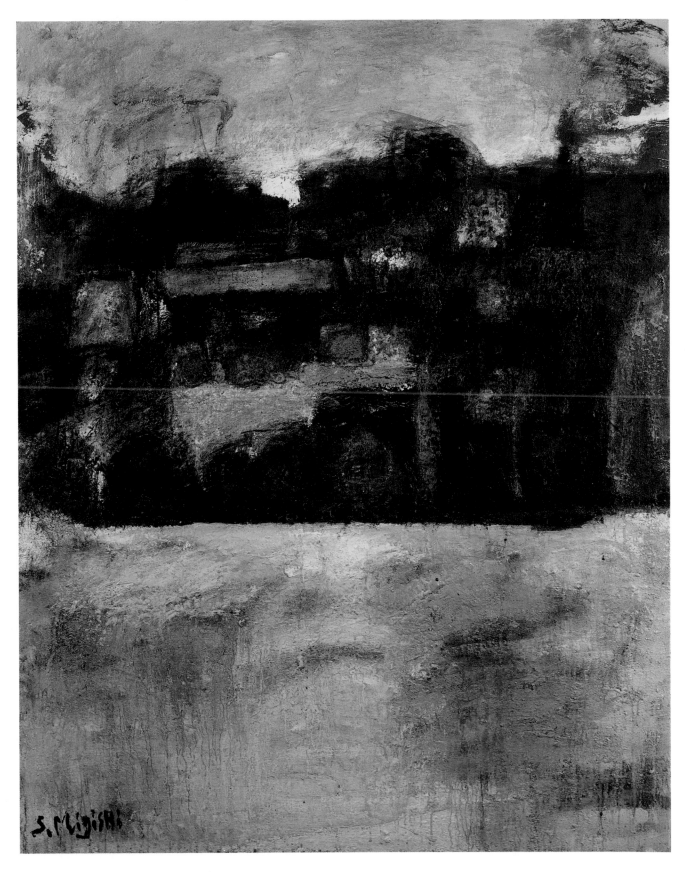

56.
ブルゴーニュの麦畑
Wheat Field in Bourgogne
1980

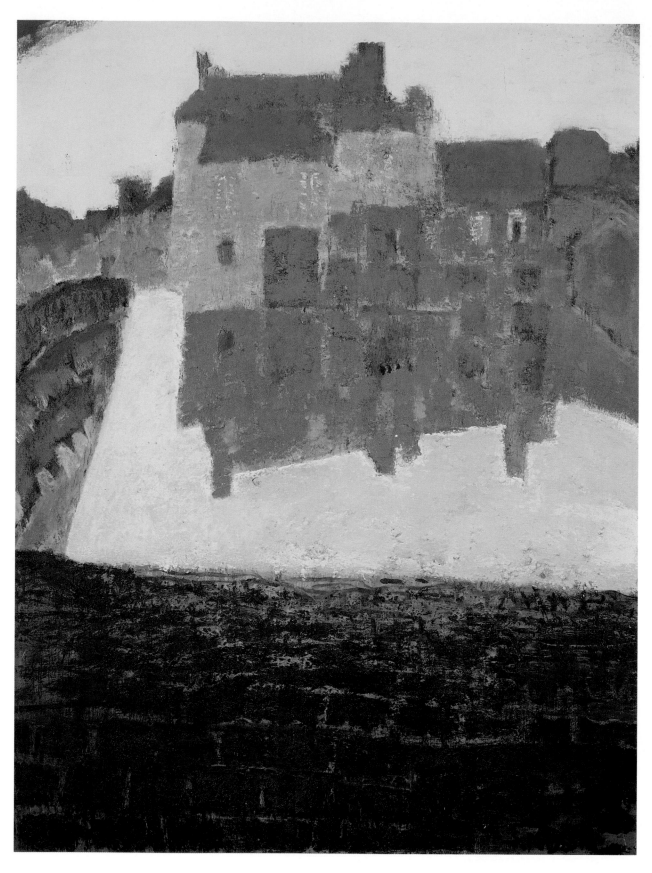

57.
トネールの白い川
White River in Tonnerre
1980

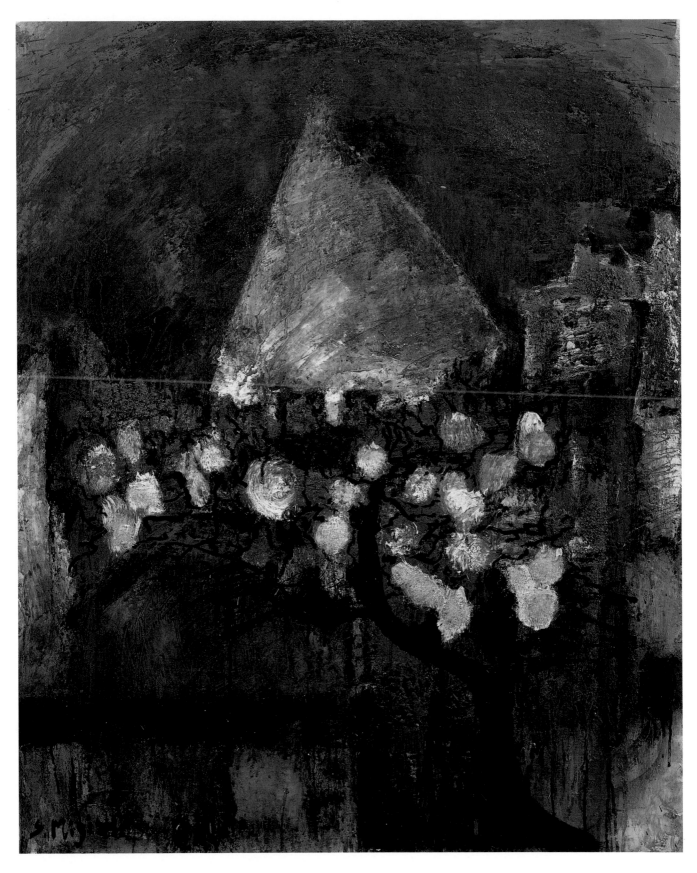

58.
さくらが咲いた
Cherry Blossoms
1980

59.
花
Flowers
1985

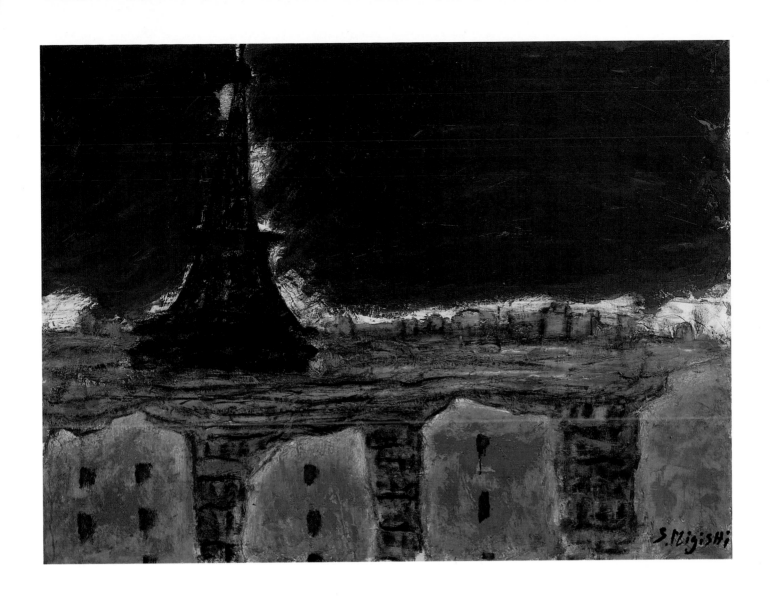

60.
エッフェル塔
Eiffel Tower
ca.1985

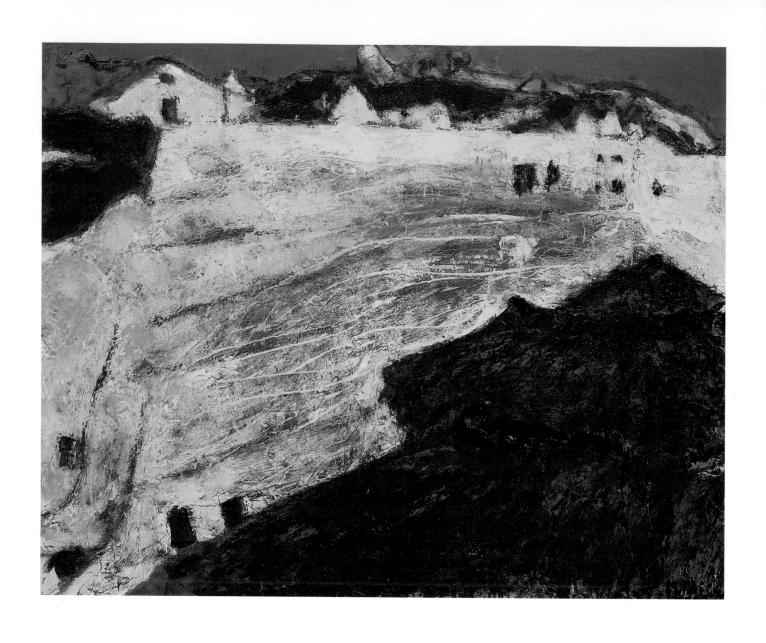

61.
アルクディア デ グアディス
Alcudia de Guadix
1986

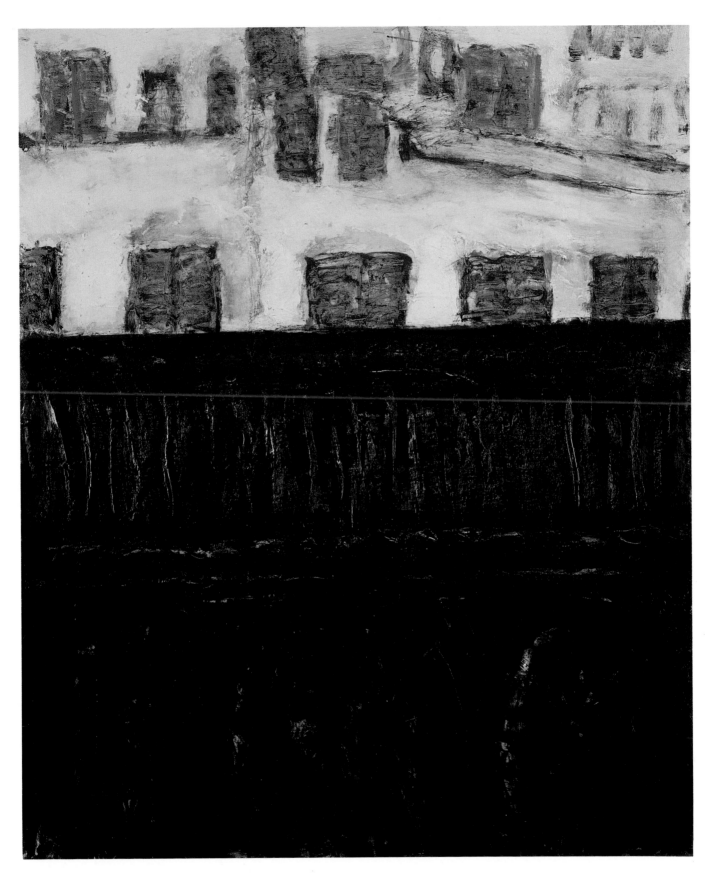

62.
モンマルトルの家
House in Montmartre
1987

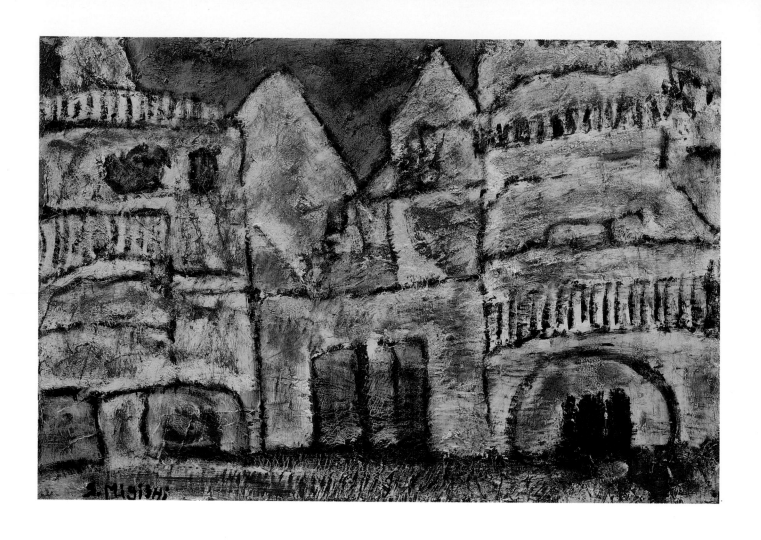

63.
カダケス
Cadaqués
1987

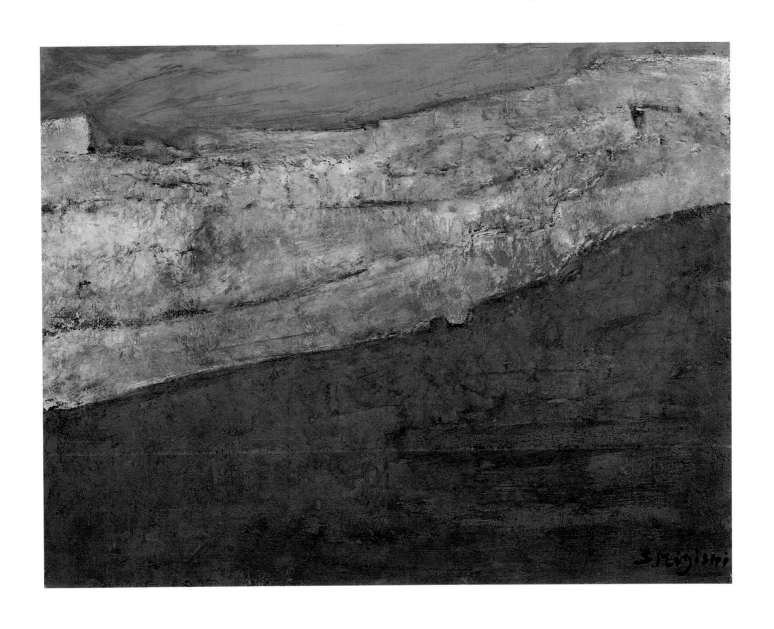

64.
崖の上（アンダルシアの）
Cliff in Andalusia
1987

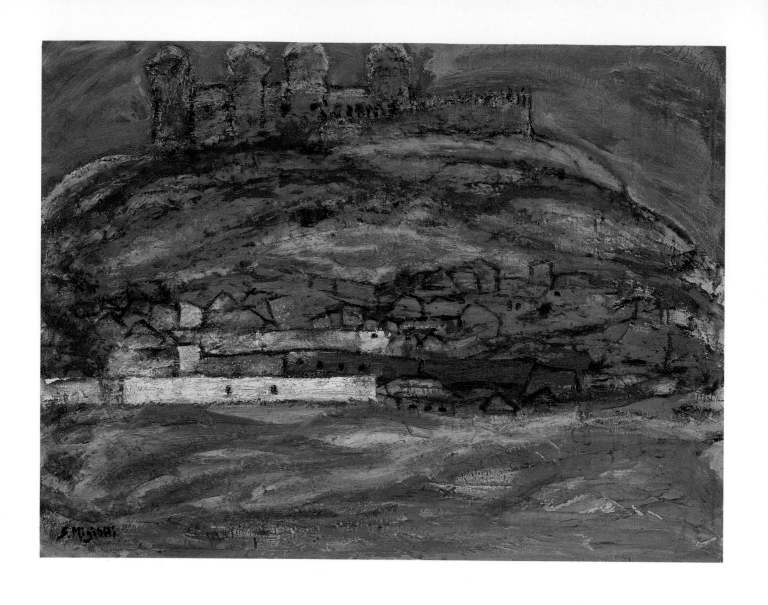

65.
ラコラオーラの城
Castle in Lacalahorra
1987

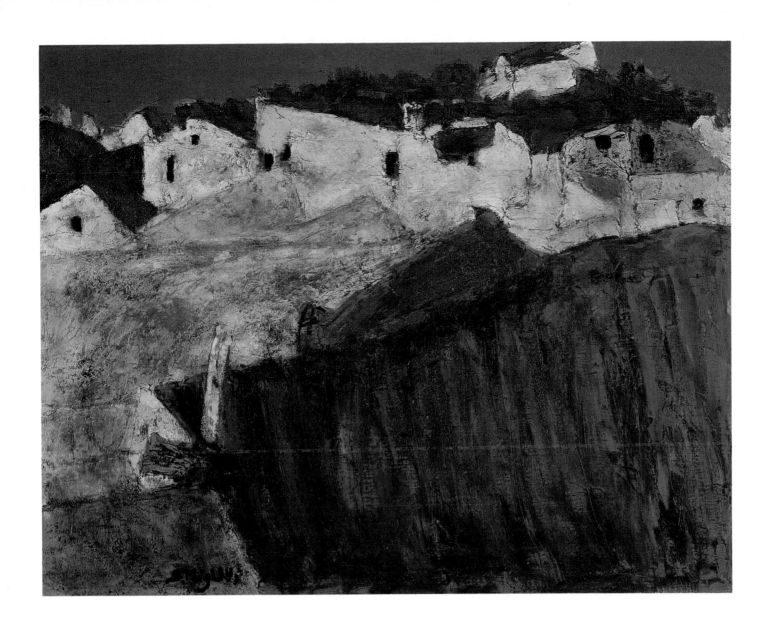

66.
赤い屋根
Red Roofs
1987

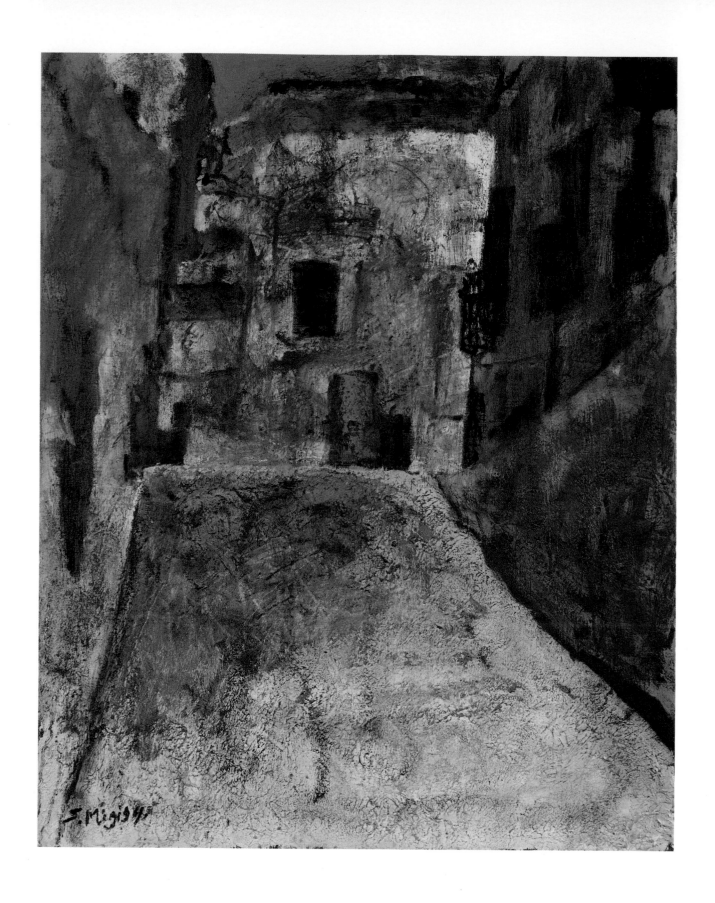

67.
坂の上へ（アンダルシア）
Hill in Andalusia
1987

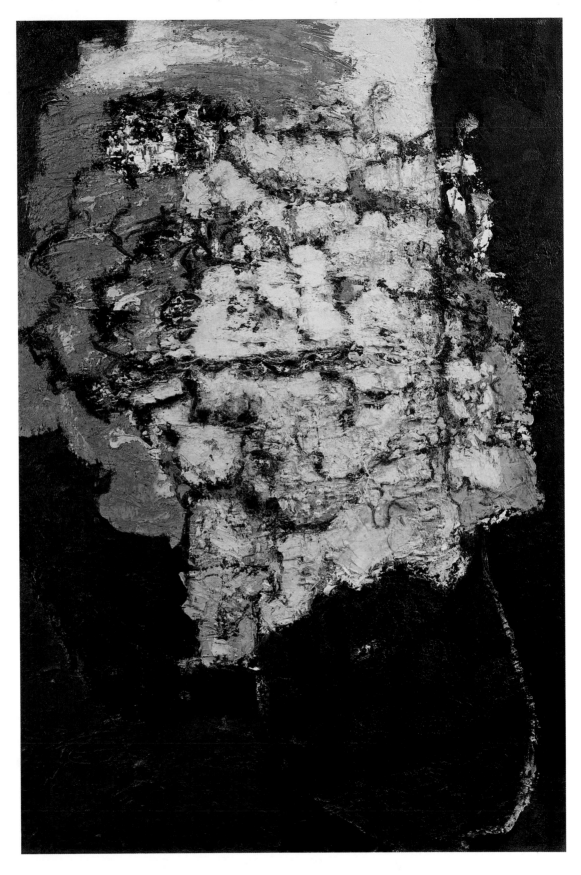

68.
花 ヴェロンにて
Flowers in Véron
1978-88

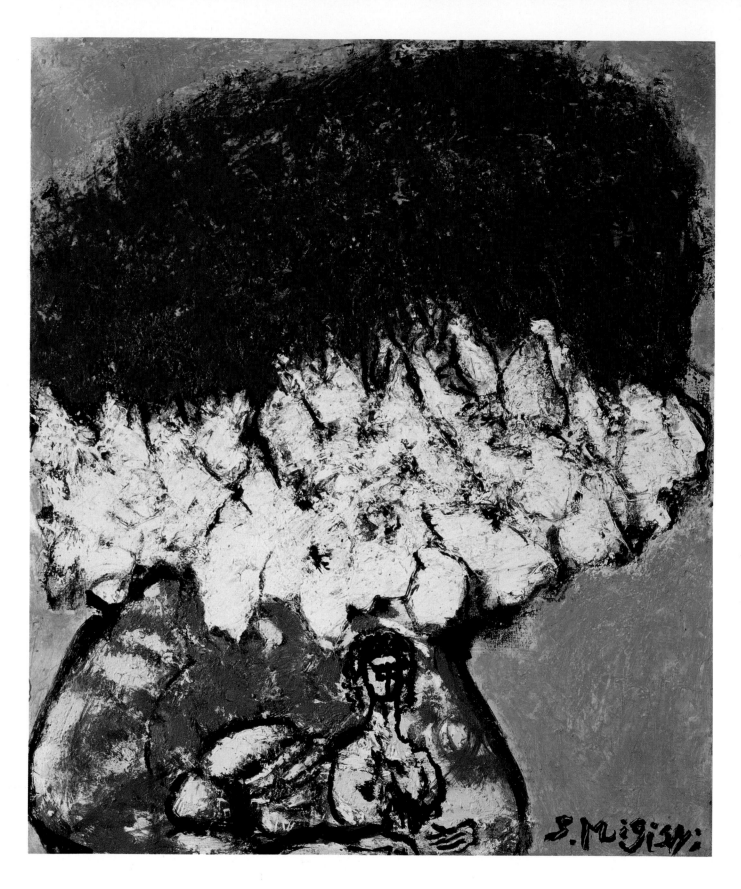

69.
花 ヴェロンにて
Flowers in Véron
1988

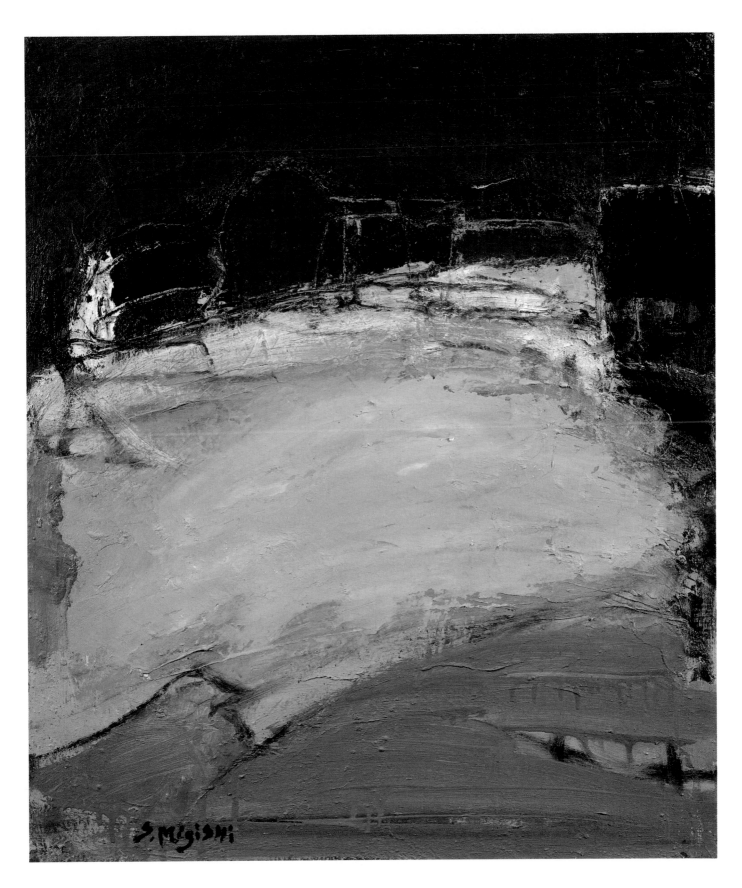

70.
小さな村
Small Village
1988

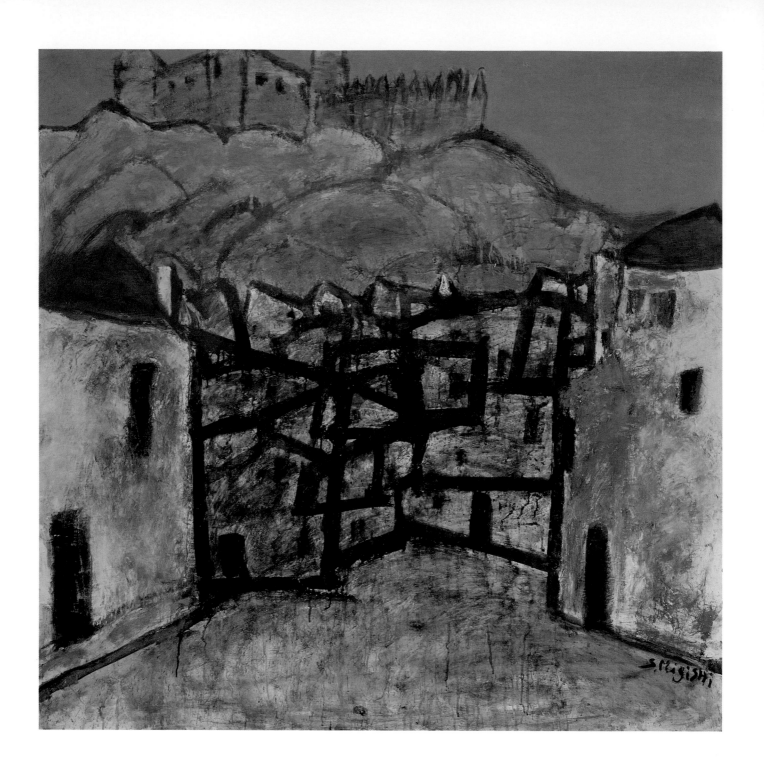

71.
城のある町
Town and Castle
1988

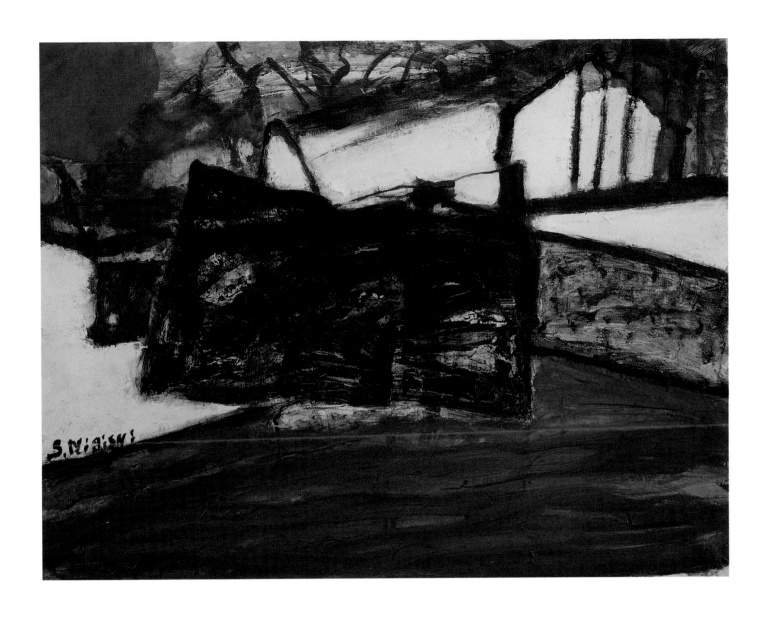

72.
アルクディア
Alcudia de Guadix
1988

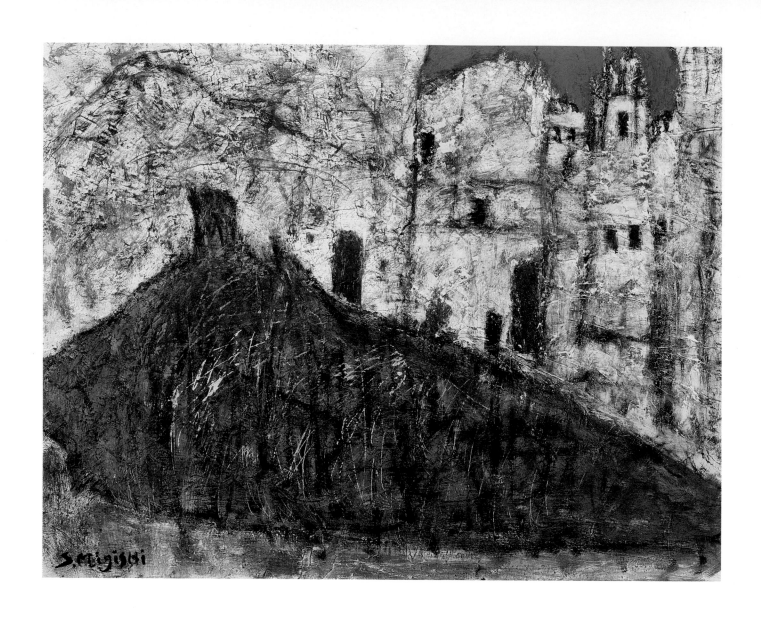

73.
アルクディア
Alcudia de Guadix
1988

100

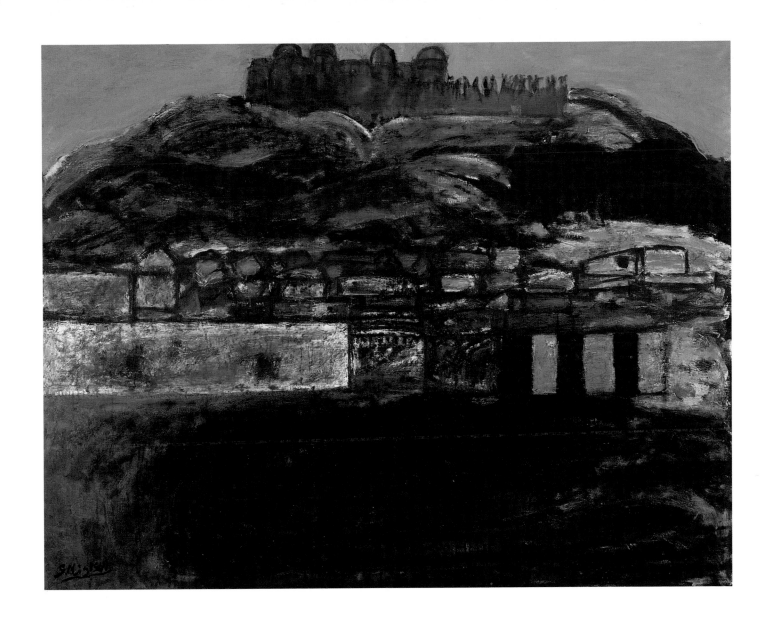

74.
ラコラオーラの城
Castle in Lacalahorra
1988

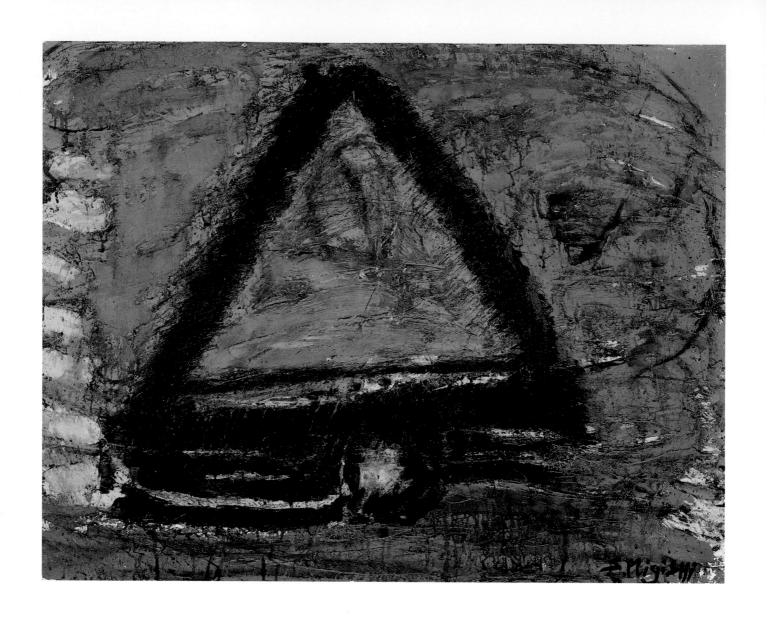

75.
作品
Composition
1988

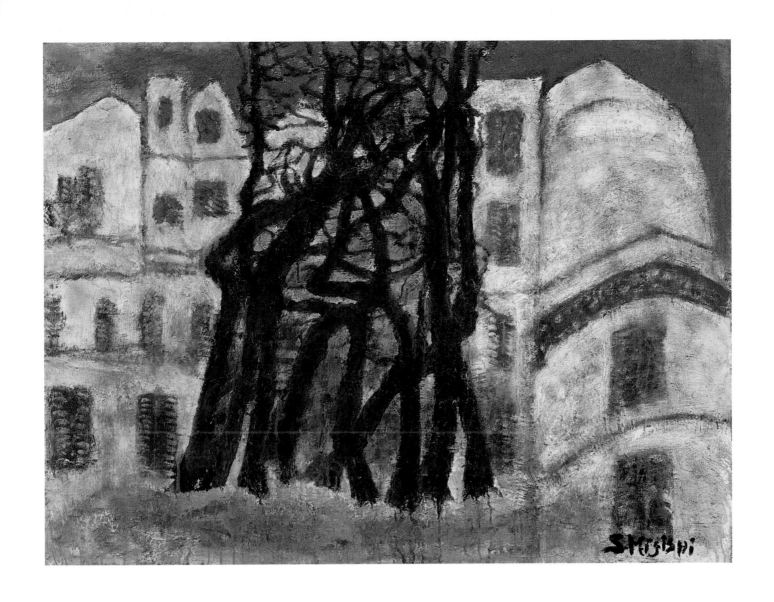

76.
春遠からじ
Approach of Spring
1979-88

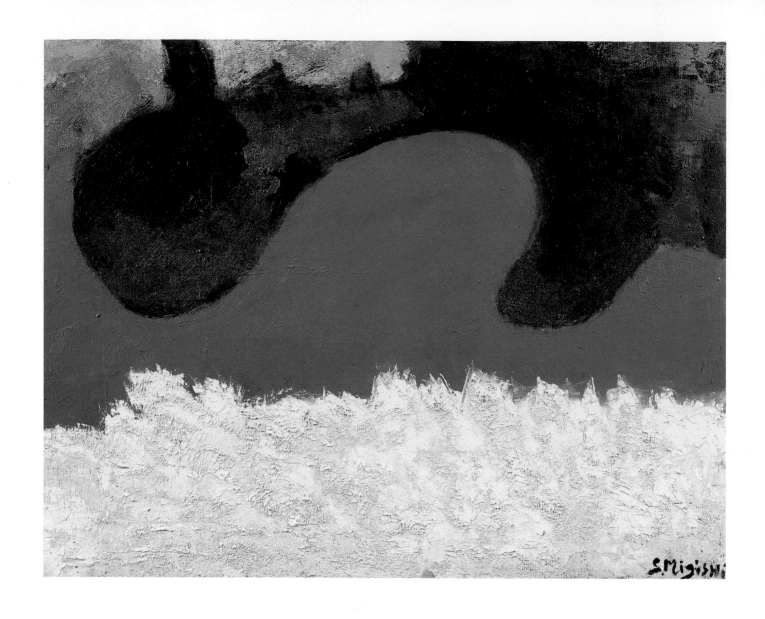

77.
ブルゴーニュの野
Field in Bourgogne
1989

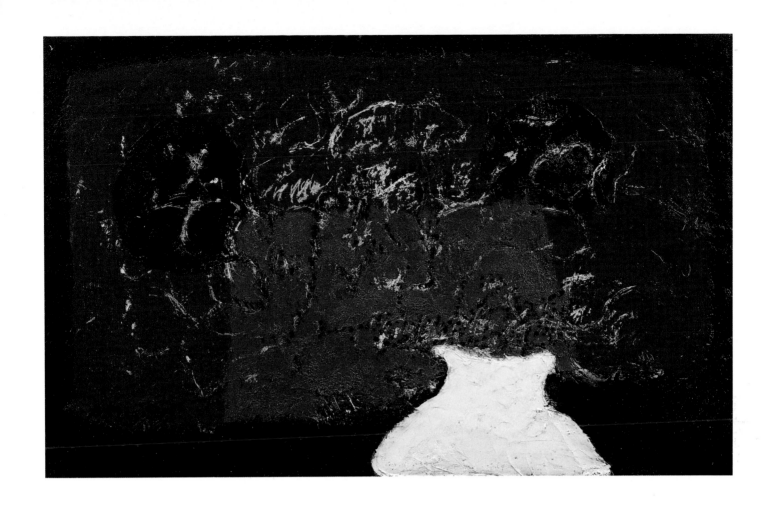

78.
花 ヴェロンにて
Flowers in Véron
1989

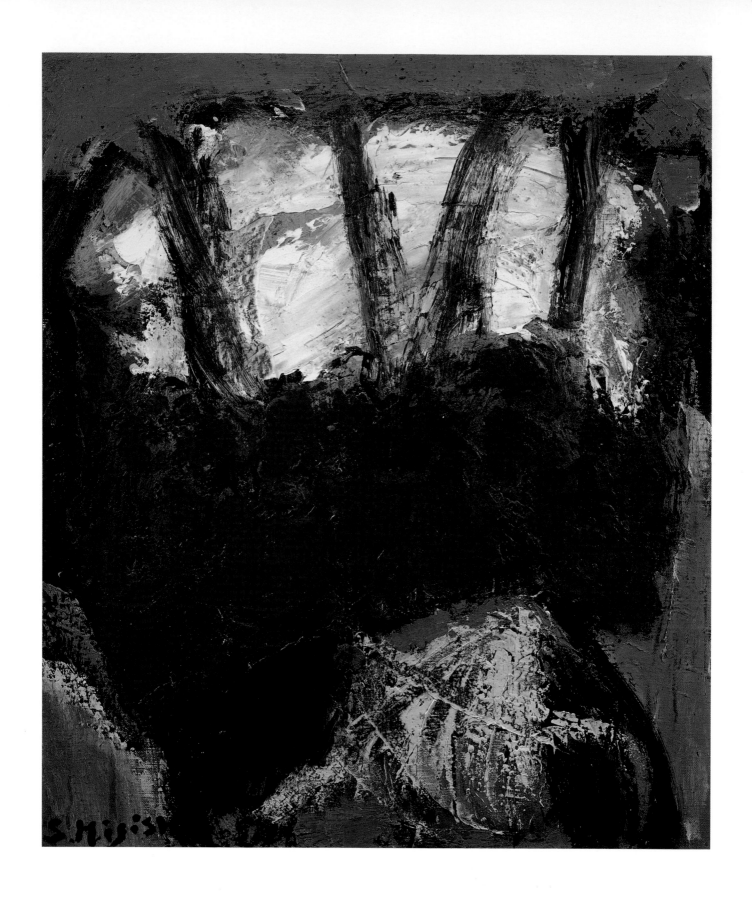

79.
花 ヴェロンにて
Flowers in Véron
1989

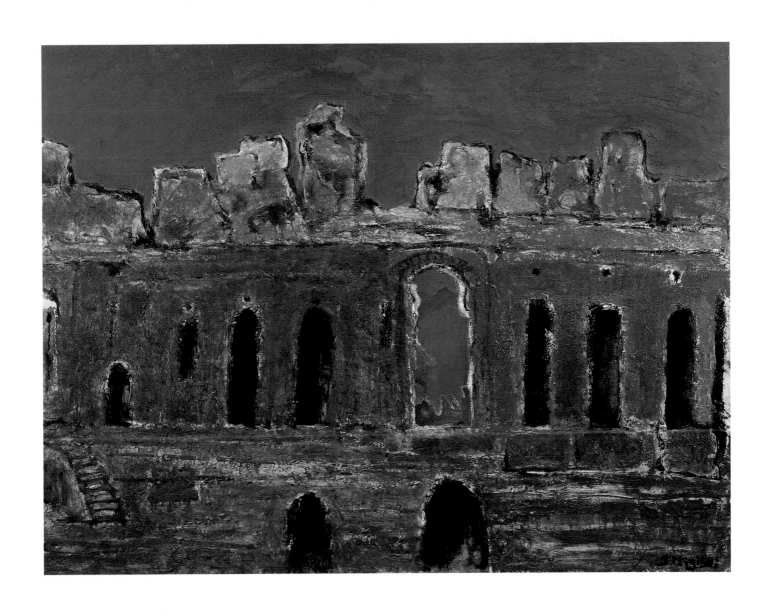

80.
テアトルの廃墟
Theater Ruins
1989

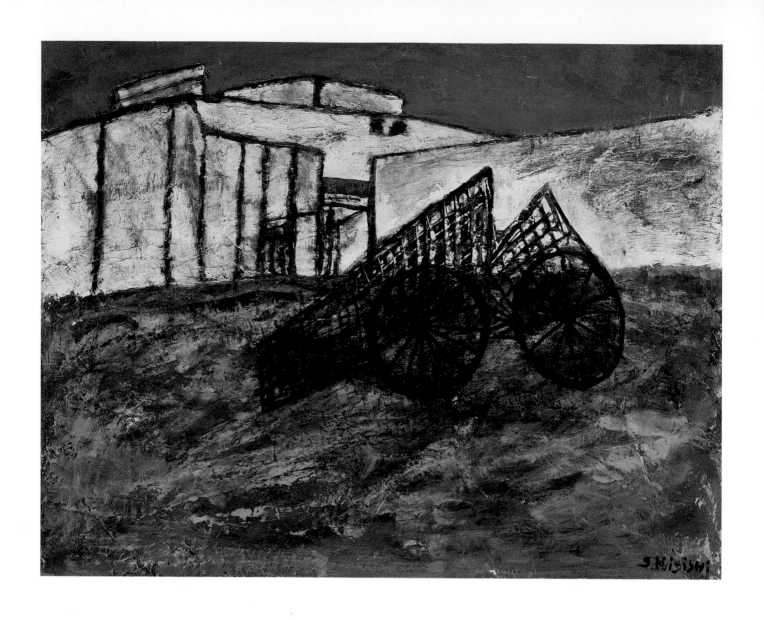

82.
ラマンチャの街にて
Road in La Mancha
1990

Exhibition Checklist

Chronology

Selected Bibliography

Exhibition Checklist

1.

Self-Portrait
1925
Oil on canvas, 12 × 8 5/8 in.
Private Collection

2.

Zebras in the Moonlight
1936
Oil on panel, 15 × 24 7/8 in.
Private Collection

3.

Interior
1936
Oil on canvas, 38 1/4 × 63 7/8 in.
Himalaya Art Museum, Nagoya

4.

Korean Study
1940
Oil on canvas, 63 7/8 × 89 1/2 in.
Himalaya Art Museum, Nagoya

5.

Interior
ca.1940
Oil on canvas, 31 5/8 × 51 1/4 in.
Himalaya Art Museum, Nagoya

6.

Interior
1942
Oil on canvas, 35 5/8 × 23 7/8 in.
Nagoya City Art Museum

7.

Still Life
1946
Oil on canvas, 20 5/8 × 17 7/8 in.
Private Collection

8.

Still Life
1948
Oil on canvas, 20 7/8 × 28 3/4 in.
Private Collection

9.

Still Life
1950
Oil on canvas, 24 × 35 3/4 in.
The National Museum of Modern Art, Tokyo

10.

Still Life in Window
1950
Oil on canvas, 42 3/8 × 20 1/8 in.
Himalaya Art Museum, Nagoya

11.

Fish and Incan Pot
1951
Oil on canvas, 23 7/8 × 35 5/8 in.
Aichi Prefectural Museum of Art

12.

Flowers and Fish
1952
Oil on canvas, 23 7/8 × 35 5/8 in.
Forestry Agency

13.

Still Life
1953
Oil on canvas, 28 5/8 × 35 3/4 in.
Himalaya Art Museum, Nagoya

14.

Mimosa Blooming in Vallauris
1954
Oil on canvas, 25 3/8 × 21 in.
Private Collection

15.

Warrior Figurine with Shield
1956
Oil on canvas, 51 1/4 × 38 1/4 in.
Himalaya Art Museum, Nagoya

16.

Ancient Figurine with Bird
1957
Oil on canvas, 51 1/4 × 35 1/8 in.
Himalaya Art Museum, Nagoya

17.

Bird and Ancient Figurine with Zither
1957
Oil on canvas, 38 1/4 × 51 1/4 in.
Bisai City Office

18.

Ancient Japanese Figurine B
1958
Oil on canvas, 38 1/4 × 51 1/4 in.
Himalaya Art Museum, Nagoya

19.

Flying Bird on Fire Mountain
1960
Oil on canvas, 35 3/4 × 28 5/8 in.
Himalaya Art Museum, Nagoya

20.

Flying Birds on Fire Mountain
1960
Oil on canvas, 25 5/8 × 31 1/2 in.
Private Collection.

21.

Flying Bird on Fire Mountain
1960
Oil on canvas, 23 5/8 × 28 1/2 in.
Private Collection

22.

Captured Birds
1960
Oil on canvas, 51 1/4 × 38 1/4 in.
Himalaya Art Museum, Nagoya

23.

Pots with Cross
1962
Oil on canvas, 39 3/8 × 31 5/8 in.
Himalaya Art Museum, Nagoya

24.

Two Pots

1962

Oil on canvas, 31 5/8×39 3/8 in.
Himalaya Art Museum, Nagoya

25.

Flying Birds

1962

Oil on canvas, 63 3/8×51 1/8 in.
The National Museum of Modern Art, Tokyo

26.

Still Life with Fish

1963

Oil on canvas, 39 3/8×31 1/2 in.
The Museum of Modern Art, Ibaraki

27.

In Praise of the Sun II

1965

Oil on canvas, 38 1/4×51 1/4 in.
Himalaya Art Museum, Nagoya

28.

Flower of Eternity

1967

Oil on canvas, 46×35 7/8 in.
Himalaya Art Museum, Nagoya

29.

Egyptian Falcon

1967

Oil on canvas, 51 1/8×63 3/8 in.
The National Museum of Modern Art, Tokyo

30.

Approaching Night

1968

Oil on canvas, 35 7/8×46 in.
Himalaya Art Museum, Nagoya

31.

Paean to the Sun

1969

Oil on canvas, 35 3/8×28 3/8 in.
Private Collection

32.

House in Cagnes-sur-Mer

1969

Oil on canvas, 23 7/8×28 3/8 in.
Private Collection

33.

Pink Houses

1971

Oil on canvas, 23 5/8×28 3/4 in.
Private Collection

34.

Bridge in Venice

1971

Oil on canvas, 28 3/4×23 5/8 in.
Private Collection

35.

White Town in Spain

1972

Oil on canvas, 28 1/2×23 5/8 in.
Private Collectoin

36.

Wall with Graffiti

1973

Oil on canvas, 36 1/4×28 1/2 in.
Aichi Prefectural Museum of Art

37.

Stone Pavement

1973

Oil on canvas, 46×35 7/8 in.
Private Collectoin

38.

Waning Moon

1973

Oil on canvas, 31 5/8×39 3/8 in.
Private Collectoin

39.

Artist's House, Venice

1973

Oil on canvas, 35 3/4×28 5/8 in.
Private Collection

40.

Houses in Venice

1973

Oil on canvas, 35 3/4×28 5/8 in.
Private Collection

41.

Mist

1973

Oil on canvas, 31 5/8×25 5/8 in.
Private Collection

42.

Houses on a Small Canal

1973

Oil on canvas, 35 3/8×28 1/8 in.
The Museum of Modern Art, Kamakura

43.

Small Canal

1973

Oil on canvas, 45 5/8×35 in.
Nagoya City Art Museum

44.

Venice

1973

Oil on canvas, 45×57 1/2 in.
Himalaya Art Museum, Nagoya

45.

Flowers III

1973

Oil on canvas, 28 5/8×35 3/4 in.
Himalaya Art Museum, Nagoya

46.

Flowers X

1974

Oil on canvas, 20 7/8×17 7/8 in.
Private Collection

47.

Narrow Canal

1974

Oil on canvas, 36 1/4×28 3/4 in.
Private Collection

48.
Flowers
1976
Oil on canvas, 20 5/8 × 17 7/8 in.
Private Collectoin

49.
Tree in Bourgogne
1978
Oil on canvas, 43 1/4 × 43 1/4 in.
Himalaya Art Museum, Nagoya

50.
Véron in Winter
1978
Oil on canvas, 35 3/4 × 28 5/8 in.
Private Collection

51.
Approaching Thunder
1979
Oil on canvas, 35 × 45 5/8 in.
Nagoya City Art Museum

52.
Purple Flowers
1979
Oil on canvas, 28 3/4 × 23 5/8 in.
Private Collection

53.
Red Earth
1979
Oil on canvas, 23 5/8 × 28 3/4 in.
Private Collection

54.
Wheat Field in Bourgogne
1979
Oil on canvas, 51 1/4 × 38 1/4 in.
Tamagawa University

55.
Camellias
1980
Oil on canvas, 25 5/8 × 17 7/8 in.
Private Collection

56.
Wheat Field in Bourgogne
1980
Oil on canvas, 57 1/4 × 44 1/8 in.
Private Collection

57.
White River in Tonnerre
1980
Oil on canvas, 51 1/4 × 38 1/4 in.
Private Collection

58.
Cherry Blossoms
1980
Oil on canvas, 35 3/4 × 28 5/8 in.
Private Collection

59.
Flowers
1985
Oil on canvas, 17 7/8 × 14 7/8 in.
Private Collection

60.
Eiffel Tower
ca.1985
Oil on canvas, 35 × 45 5/8 in.
Women's College of Fine Arts

61.
Alcudia de Guadix
1986
Oil on canvas, 31 7/8 × 38 3/8 in.
Private Collection

62.
House in Montmartre
1987
Oil on canvas, 36 1/4 × 28 3/4 in.
Private Collection

63.
Cadaqués
1987
Oil on canvas, 19 5/8 × 28 3/4 in.
Private Collection

64.
Cliff in Andalusia
1987
Oil on canvas, 28 3/4 × 36 1/4 in.
Collection Shōji Takahashi

65.
Castle in Lacalahorra
1987
Oil on canvas, 35 × 45 5/8 in.
Private Collection

66.
Red Roofs
1987
Oil on canvas, 31 7/8 × 39 3/8 in.
Private Collection

67.
Hill in Andalusia
1987
Oil on canvas, 36 1/4 × 28 3/4 in.
Collection Shōji Takahashi

68.
Flowers in Véron
1978-88
Oil on canvas, 36 1/4 × 23 5/8 in.
Private Collection

69.
Flowers in Véron
1988
Oil on canvas, 21 5/8 × 18 1/8 in.
Private Collection

70.
Small Village
1988
Oil on canvas, 28 3/4 × 23 5/8 in.
Private Collection

71.
Town and Castle
1988
Oil on canvas, 47 1/4 × 47 1/4 in.
Collection Shōji Takahashi

72.

Alcudia de Guadix

1988

Oil on canvas, 28 3/4×36 1/4 in.
Private Collection

73.

Alcudia de Guadix

1988

Oil on canvas, 28 3/4×36 1/4 in.
Private Collection

74.

Castle in Lacalahorra

1988

Oil on canvas, 51 1/8×63 3/4 in.
Private Collection

75.

Composition

1988

Oil on canvas, 28 3/4×36 1/4 in.
Private Collection

76.

Approach of Spring

1979–88

Oil on canvas, 35×45 5/8 in.
Private Collection

77.

Field in Bourgogne

1989

Oil on canvas, 28 3/4×36 1/4 in.
Collection Shōji Takahashi

78.

Flowers in Véron

1989

Oil on canvas, 23 5/8×36 1/4 in.
Collection Shōji Takahashi

79.

Flowers in Véron

1989

Oil on canvas, 21 5/8×18 1/8 in.
Private Collection

80.

Theater Ruins

1989

Oil on canvas, 44 7/8×57 1/2 in.
Private Collection

81.

Taormina

1989

Oil on canvas, 35×45 5/8 in.
Private Collection

82.

Road in La Mancha

1990

Oil on canvas, 28 3/4×36 1/4 in.
Private Collection

Chronology

Compiled by Masatoshi Nakajima

Fig. 14.
Shukutoku Girls' High School days, *ca.* 1920.

Fig. 15.
Women's Arts School days, *ca.* 1922.

1905 (Meiji 38)
Setsuko Migishi born on January 3rd in Okoshi (the present-day Bisai City), Nakajima-gun, Aichi Prefecture. Mother was Kiku and father Eizaburō Yoshida, a wealthy landowner and later woolen manufacturer. Setsuko born afflicted with dislocated hip, a congenital disorder which is surgically corrected at age of six.

1917 (Taishō 6) Age 12
April: Enters Shukutoku Girls' High School in Nagoya, living in school dormitory.

1920 (Taishō 9) Age 15
Eizaburō Yoshida's woolen business bankrupt by Depression. Migishi decides to become a painter to recover family honor.

1921 (Taishō 10) Age 16
March: Graduates Shukutoku Girls' High School. Fails entrance exam for woman's medical school. Commences art studies with Saburōsuke Okada (1869-1939), professor at Tōkyō Academy of Fine Arts (present Tōkyō National University of Fine Arts and Music). Okada was first Japanese painter to study in France on government scholarship, studying under Louis-Joseph-Raphaël Collin. After returning to Japan in 1902, he became prominent figure in the "Western-style" movement in Japanese painting.

1922 (Taishō 11) Age 17
April: Enters Women's Arts School (present Women's College of Fine Arts) in Tōkyō.
November: Meets Kōtarō Migishi (1903-1934). They had both exhibited around the same time, in 1920, with the Second Sha Exhibition.

1923 (Taishō 12) Age 18
Summer: Submissions made with Ayako Jimbo rejected by Nika-kai, large art organization that holds enormous yearly exhibitions.

1924 (Taishō 13) Age 19
March: Graduates from Women's Arts School at the top of class.
September: Marries Kōtarō Migishi. Set up house together in Sugamo near Somei Cemetery.

1925 (Taishō 14) Age 20
January: Gives birth to first daughter, Yōko.
March: Participates for first time in Third Exhibition of the Shun'yō Society (Shunyō-kai Daisankai-ten), held at Takenodai Exhibition Hall (Takenodai Chinretsukan) in Ueno; contributes self-portrait. Established in 1922, the Shun'yō

Society was one of the representative associations of Western-style painting in Japan. (It should be noted that, in Japan, a distinction has always been made between "Western" and "Japanese" styles of painting. The former involves the use of oil paints and other materials introduced from Europe; the latter involves the use of traditional pigments obtained from plants and other natural sources.)

April: Together with her Women's Arts School fellow-students, such as Hitoyo Kai and Kōko Fukazawa, establishes the Women's Western-style Painting Association (Fujin Yōga Kyōkai). Group holds its first exhibition at the Matsuzakaya department store in Ginza, Tōkyō.

August: Setsuko, her husband Kōtarō and Hideo Niwa go to Kōtarō's hometown, Sapporo, and hold three-person exhibition at Sapporo Commercial Conference Hall (Sapporo Shōgyō Kaigijō).

1926 (Taishō 15/Shōwa 1) Age 21

February: Exhibits *Still Life* in Fourth Exhibition of the Shun'yō Society.

1928 (Shōwa 3) Age 23

March: Gives birth to second daughter, Kyōko.
April: Exhibits *Flowers and Fruit* in Sixth Exhibition of the Shun'yō Society.
May: Visits Sapporo with Kōtarō and Seiji Chōkai, remaining for half a year.
October: Included in three-person exhibition with Kōtarō and Seiji Chōkai at Imai department store.

1929 (Shōwa 4) Age 24

April: Exhibits *The Clock Tower* in Seventh Exhibition of the Shun'yō Society.
May: Moves into a newly-built atelier in Saginomiya, Nakano Ward, Tōkyō.

1930 (Shōwa 5) Age 25

April: Exhibits *Marionnette* and other works in Eighth Exhibition of the Shun'yō Society.
September: Gives birth to first son, Kōtarō.

1931 (Shōwa 6) Age 26

April: Exhibits *Peaches* in Ninth Exhibition of the Shun'yō Society.

1932 (Shōwa 7) Age 27

March: Leaves the Shun'yō Society. Begins to exhibit with her husband's group, the Independent Art Association, formed two years earlier. Shows two works, including *Flowers and Fruit*, in Second Exhibition of the Independent Art Association (Dokuritsu Bijutsu Kyōkai) held at Tōkyō-fu Bijutsukan. The Independent Art Association was already considered a representative Japanese group of Western-style painters. The basis of their style was Fauvism.

1933 (Shōwa 8) Age 28

March: Exhibits *At the Window* and other works in Third Exhibition of the Independent Art Association.

1934 (Shōwa 9) Age 29

March: Exhibits *The Corner, Yōko in a Sailor Suit* and other works in Fourth Exhibition of the Independent Art Association.
June: Setsuko and Kōtarō travel to Kyōto, Nara and Ōsaka.

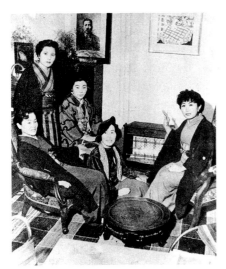

Fig. 16.
With members of the Shichisai Society, 1936.

July: On July 1 Kōtarō dies at age of thirty-one. Setsuko left alone with three small children to raise. A memorial exhibit of Kōtarō's drawings, together with some of Setsuko's work, held at Kōbe Gallery in Kōbe.

September: Josō-kai, a group consisting of Migishi, Mari Ogawa, Ritsuko Minemura and other women artists who exhibit with the Independent Art Association, formed. First exhibition held at Tōkyōdō in Kanda, Tōkyō. Migishi contributes *Tropical Fish* and other works. Continues to exhibit regularly with this group through 1938.

1935 (Shōwa 10) Age 30

March: Exhibits *The Peach-Colored Cloth*, *Window* and *The Red Cloth* in Fifth Exhibition of the Independent Art Association; awarded D. Prize (named for an anonymous donor).

August: Solo show at Bijutsu Shinronsha Gallery in Ōsaka.

1936 (Shōwa 11) Age 31

January: Seven women painters, including Migishi, Haruko Hasegawa, Yoneko Saeki and Eiko Fujikawa, form the new association the Shichisai Society (Shichisai-kai).

April: First Exhibition of the Shichisai Society (Shichisai-kai Dai-ikkai-ten) held at Seijusha Gallery in Ginza, Tōkyō. Includes Migishi's *Zebras in the Moonlight* and two other works. Also shows *Interior*, *Landscape* and *Night* in Sixth Exhibition of the Independent Art Association and becomes associate member of organization.

August: Solo show at Bijutsu Shinronsha Gallery in Ōsaka.

1937 (Shōwa 12) Age 32

March: Exhibits *Landscape*, *Interior* and *Figures* in Seventh Exhibition of the Independent Art Association.

April: Exhibits *Mist* and other works in Second Exhibition of the Shichisai Society at Nihon Salon in Ginza.

October: Solo exhibition of recent paintings, ten oil paintings and ten gouaches, at Galerie Nichidō in Ginza, Tōkyō.

Also Meets Western-style painter Keisuke Sugano (1909-1963), just returned from France.

1938 (Shōwa 13) Age 33

March: Exhibits *A Herd of White Horses*, *Interior* and *Window* in Eighth Exhibition of the Independent Art Association.

November: Solo show at Galerie Nichidō in Ginza, Tōkyō; includes about twenty watercolors.

December: Solo show of watercolors at Bikōsha in Ōsaka.

1939 (Shōwa 14) Age 34

March: Exhibits *February*, *May* and *July* in Ninth Exhibition of the Independent Art Association.

November: Decides to stop exhibiting with the Independent Art Association, whose bylaws prohibit women from becoming regular members of the association. On the suggestion of Kei Satō, becomes member of Shinseisaku-ha Association (Shinseisaku-ha Kyōkai), established in 1936 to further the principles of modernism in art. Exhibits seven works titled *Interior* in Fourth Exhibition of the Shinseisaku-ha Association, held at the Tōkyō-fu Bijutsukan.

Fig. 17. *ca.* 1938.

Fig. 18. *ca.* 1940.

1940 (Shōwa 15) Age 35

April: Travels in Korea and northeast China. Solo show at Chōjiya in Seoul, Korea.
September: Exhibits studies made in Korea in Fifth Exhibition of the Shinseisaku-ha Association.
October: Exhibits *Interior* in *An Exhibition of Art in Celebration of the Year 2600* (Kigen Nisen-roppyaku-nen Hōshuku Bijutsu-ten), held at Tōkyō-fu Bijutsukan.

1941 (Shōwa 16) Age 36

May: Exhibits *Still Life* in Shinseisaku-ha Association Spring Exhibition (Shinseisaku-ha Kyōkai Shunki-ten), held at Shiseidō Gallery in Ginza, Tōkyō.
September: Exhibits two versions each of *Still Life* and *Interior* in Sixth Exhibition of the Shinseisaku-ha Association.

1942 (Shōwa 17) Age 37

May: Exhibits *Interior* and *Still Life* in Shinseisaku-ha Association Spring Exhibition, held at Galerie Nichidō in Ginza, Tōkyō.
September: Exhibits *Festival, Still Life* and three versions of *Interior* in Seventh Exhibition of the Shinseisaku-ha Association.

1943 (Shōwa 18) Age 38

September: Exhibits series of five paintings titled *Still Life*, along with *Interior* and *Flowers*, in Eighth Exhibition of the Shinseisaku-ha Association.

1944 (Shōwa 19) Age 39

May: Exhibits *Still Life* in Shinseisaku-ha Association Spring Exhibition, held at Ya'ataya Gallery in Tōkyō.
September: Under the new govermental regulations regarding art exhibitions, shows offering works for sale prohibited.

1945 (Shōwa 20) Age 40

August: World War II ends.
September: Solo show at Galerie Nichidō in Ginza, Tōkyō. First post-war exhibition held in Tōkyō.

1946 (Shōwa 21) Age 41

September: Tenth Exhibition of the Shinseisaku-ha Association takes place. Migishi exhibits series of five paintings titled *Flowers* and a series of three others titled *Still Life*.
November: Participates in Contemporary Women Artists' Exhibition (Gendai Joryū Gaka-ten), held at Hokusō Gallery in Nihombashi, Tōkyō. During this show, Setsuko Migishi and Eiko Fujikawa propose formation of an association of women painters; which results in establishment of the Women's Art Association (Joryū Gaka Kyōkai). Painters wishing to exhibit their works through the association do so freely, without being subject to a panel of judges, and no prizes are awarded.

Fig. 19.
With members of the Women's Art Association, 1946.

1947 (Shōwa 22) Age 42

February: Attends the inauguration of the Women's Art Association.
May: Exhibits *Interior* in *Contemporary Art Exhibition for the Enforcement of the New Constitution and in Commemoration of the Twentieth Anniversary of the Tōkyō Metropolitan Art Gallery.* (In 1943, the Tōkyō-fu Bijutsukan changed its name to the Tōkyō-to

Bijutsukan; until 1953, the English version of this name was the Tōkyō Metropolitan Art Gallery.)

June: Exhibits *Flowers* in First Exhibition of the Federation of Art Organizations (Dai-ikkai Bijutsu Dantai Rengō-ten), held at the Tōkyō Metropolitan Art Gallery. Exhibits regularly with this group until 1951.

July: Exhibits *Still Life* in First Independent Exhibition of the Women's Art Association (Joryū Gaka Kyōkai Dai-ikkai Indépendent-ten), held at the Tōkyō Metropolitan Art Gallery.

September: Exhibits two versions of *Still Life* and three of *Flowers* in Eleventh Exhibition of the Shinseisaku-ha Association.

1948 (Shōwa 23) Age 43

March: Exhibits *Flowers* and two versions of *Still Life* in Second Independent Exhibition of the Women's Art Association.

July: Marries painter Keisuke Sugano.

September: Exhibits *Pink Flowers*, *A Corner of the Room* and other works in Twelfth Exhibition of the Shinseisaku-ha Association.

1949 (Shōwa 24) Age 44

February: Exhibits *Flowers* in First Nihon Independents Exhibition (Dai-ikkai Nihon Yomiuri Indépendents-ten), held at the Tōkyō Metropolitan Art Gallery.

April: Exhibits *Still Life* and *Floral Improvisations* in Third Independent Exhibition of the Women's Art Association.

July: Essays published by the Asahi newspaper company under the title *Wings of the Spirit of Beauty* (Bishin-no tsubasa).

September: Exhibits three paintings titled *Flowers* and other works in Thirteenth Exhibition of the Shinseisaku-ha Association.

1950 (Shōwa 25) Age 45

January: Exhibits ten still lifes, works done between 1942 and 1949, in *Representative Modern Paintings of Fifteen Japanese Artists*, held at the Takashimaya department store at Nihombashi, Tōkyō.

March: *Still Life* chosen for First Selected Masterpieces Art Exhibition, sponsored by the Asahi newspaper company (*Asahi Shimbun*) and held at the Mitsukoshi department store in Nihombashi, Tōkyō.

April: Exhibits three works titled *Crystal* in Fourth Independent Exhibition of the Women's Art Association.

September: Exhibits six paintings titled *Still Life* in Fourteenth Exhibition of the Shinseisaku-ha Association.

October: Solo exhibition at the Daimaru department store in Sapporo, Hokkaidō.

Fig. 20. *ca.* 1951.

1951 (Shōwa 26) Age 46

January: *Still Life and Goldfish* and *Still Life and Gardenia* chosen for Second Selected Masterpieces Art Exhibition.

March: *Goldfish* Ministry of Education's art purchase for 1950. Also awarded Education Minister's Prize for Fostering the Arts.

September: Two art organizations, the Shinseisaku-ha Association and the Japanese-style Painting Group for Creative Art (Nihonga Dantai Sōzō Bijutsu) combine to form new organization called the Shinseisaku Association. Migishi exhibits *Still Life*, *Head*, *Venetian Vase*, *Birdcage*, *Black and White Table*, *Andersson's Vase and Bird* and *Goldfish and Crucifix* in Fifteenth Exhibition of the Shinseisaku

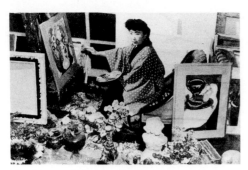

Fig. 21. *ca.* 1952.

Association, held at the Tōkyō Metropolitan Art Gallery.

October: Participates in first post-war overseas exhibition, the First São Paulo Biennial at the São Paulo Museum of Modern Art, exhibiting *Flowers*. Solo exhibition at the Daimaru department store in Sapporo, Hokkaidō.

1952 (Shōwa 27) Age 47

April: Exhibits *Flowers* and *Still Life* in Fourth Nihon Independents Exhibition (Dai-yonkai Nihon Indépendents-ten).

May: Invited to participate in First International Art Exhibition, Japan (Dai-ikkai Nihon Kokusai Bijutsu-ten), sponsored by the Mainichi newspaper company. Contributes *Two Incan Vases, Eels and Sea Bream* and *Flowers and Fish*. By popular vote, her works named best of exhibition. *Black and White Table* exhibited at Eighth Salon de Mai in Paris.

June: Exhibits *Andersson's Vase and Bird* and other works in the *Twentieth-Century Masterpieces* exhibition, held in Paris. Solo show at the Iwataya department store in Fukuoka.

September: Exhibits *Fish and Incan Pot, Flowers, Birdcage and Head, Flowers and Fish* and *Window* in Sixteenth Exhibition of the Shinseisaku Association.

October: Exhibits *Goldfish* in Eighteenth Pittsburgh International Contemporary Art Exhibition. Solo show at Kabutoya Gallery in Ginza, Tōkyō.

December: *Still Life—Night Composition* included in the *Exhibition of Japanese Modern Art: A Retrospective and Survey Organized by the National Museum of Modern Art, Tōkyō* (Tōkyō Kokuritsu Kindai Bijutsukan-no Kikaku-ten: Nihon Kindai Bijutsu-ten [Kindai Kaiga-no Kaiko to Tenbō]). From this time on representative works by Migishi often included in exhibitions set up by the museum. Solo show at Umeda Gallery in Ōsaka.

1953 (Shōwa 28) Age 48

February: Exhibits *Flowers* in Fifth Nihon Independents Exhibition.

May: Invited to exhibit in Second International Art Exhibition, Japan. Submits two works entitled *Still Life with Lamp*.

September: Exhibits *The Yellow Crystal Vase, Clouds in Motion, Gardenias, Still Life, Captured Bird, Plaice* and *Two Pots* in Seventeenth Exhibition of the Shinseisaku Association.

October: Divorces Keisuke Sugano. Son, Kōtarō, leaves to study in France.

1954 (Shōwa 29) Age 49

January: *Still Life with Birdcage* chosen for Fifth Selected Masterpieces Art Exhibition. With Fuku Akino and Yuki Ogura, Migishi holds First Exhibition of the Three Women Painters' Group (Dai-ikkai Joryū Sannin-ten) at the Matsuzakaya department store in Ginza, Tōkyō. Exhibits regularly with this group through 1958.

February: Exhibits *Still Life* in Sixth Nihon Independents Exhibition.

March: Book of paintings, entitled *S. Migishi*, published by Bijutsu Shuppansha. Visits France for first time.

May: Solo exhibition at Chuō Kōronsha Gallery.

September: Solo exhibition at Umeda Gallery in Ōsaka. Travels to Spain.

October: Stays in Cagnes in southern France.

December: Solo show at Kabutoya Gallery in Ginza.

1955 (Shōwa 30) Age 50

May: Travels to Italy, returning to Japan in July.

November: Solo exhibition at Kabutoya Gallery in Ginza.

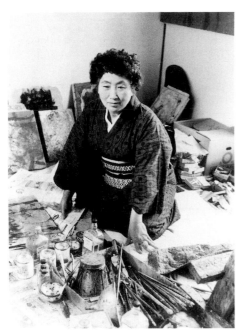

Fig. 22. In the atelier of Karuizawa, 1957.

1956 (Shōwa 31) Age 51

February: Solo exhibition at Matsuzakaya department store in Nagoya.

May: Invited to participate in Second Contemporary Japanese Art Exhibition, sponsored by the Mainichi newspaper company and held at the Tōkyō Metropolitan Art Gallery. Contributes *Still Life* and *Incan Vase*.

September: Exhibits a series of five paintings titled *Haniwa* in Twentieth Exhibition of the Shinseisaku Association. (Haniwa are clay funerary figurines found in ancient burial mounds.)

1957 (Shōwa 32) Age 52

January: *Warrior Figurine with Shield* chosen for Eighth Selected Masterpieces Art Exhibition.

May: Invited to exhibit in Fourth International Art Exhibition, Japan. Contributes *Haniwa*.

July: Exhibits *Goldfish* in *Modern Art Exhibition: Masterpieces of the Last Ten Years* (Gendai Bijutsu Jūnen-no Kessaku-ten), held at the Tōyoko department store, Shibuya, Tōkyō.

September: Exhibits *Bird and Ancient Figurine with Zither* in Twenty-fist Exhibition of the Shinseisaku Association.

October: Exhibits six drawings, including *Flowers and Fish* and *Warrior Figurine with Shield*, in Exhibition of Seventeen Artists Organized by the National Museum of Modern Art, Tōkyō (Tōkyō Kokuritsu Kindai Bijutsukan no Kikaku-ten: Jushi-chinin no Sakka).

November: Exhibition of sketches sponsored by the Asahi newspaper company at the Matsuya department store.

Suffers from ill health, and spends great deal of year recuperating at mountain villa in Karuizawa.

1958 (Shōwa 33) Age 53

January: *Bird and Haniwa* chosen for Ninth Selected Masterpieces Art Exhibition.

February: Exhibits two works titled *Still Life* in Second Exhibition of Le Groupe International de L'Art Figuratif (Dai-nikai Kokusai Gushōha-ten), organized with the cooperation of the Asahi newspaper company and held at the Mitsukoshi department store in Nihombashi, Tōkyō.

May: Invited to exhibit in Third Contemporary Japanese Art Exhibition. She submits two works titled *Ancient Japanese Figurine*.

August: Invited to exhibit in Twelfth Shinju Society Exhibition (Shinju-kai Dai-jūnikai-ten), held at the Mitsukoshi department store in Nihombashi. She contributes three works titled *Still Life*.

September: Exhibits *Bird and Fish*, *Fish*, *Fish and Birds in Flight*, *Bird (Haniwa) and Fish* and two works titled *Still Life* in Twenty-second Exhibition of the Shinseisaku Association.

1959 (Shōwa 34) Age 54

January: *Fish and Bird in Flight* selected for Tenth Commemorative Selected Masterpieces Art Exhibition. *Warrior Figurine with Shield* selected for *Post-war Masterpieces* exhibition, organized by the National Museum of Modern Art, Tōkyō (Tōkyō Kokuritsu Kindai Bijutsukan no Kikaku-ten: Sengo no Shūsaku).

May: Invited to exhibit in Fifth International Art Exhibition, Japan. She submits work titled *Two Figures*.

July: Solo exhibition of collages at Nire no Ki Gallery in Ginza, Tōkyō.

1960(Shōwa 35) Age 55

April: Exhibits *Ancient Japanese Figurine* in Third Exhibition of Le Groupe International de L'Art Figuratif, held at the Matsuzakaya department store in Ginza, Tōkyō.

May: Invited to exhibit in Fourth Contemporary Japanese Art Exhibition. She submits two paintings titled *Ancient Japanese Figurine*.

September: Exhibits five works titled *Flying Bird on Fire Mountain* in Twenty-fourth Exhibition of the Shinseisaku Association.

November: Solo show at Kabutoya Gallery, where she exhibits the series *At the Volcano*.

1961(Shōwa 36) Age 56

May: Invited to exhibit in Sixth International Art Exhibition, Japan, and submits painting titled *Work*.

August: Exhibits five works, *A to E*, of the series *Flying Birds*.

September: Exhibits two paintings titled *Ancient Japanese Figurine* and another work titled *Captured Birds* in Twenty-fifth Exhibition of the Shinseisaku Association.

1962(Shōwa 37) Age 57

April: Exhibits *Still Life with Shells* and *Flying Birds on Fire Mountain* in Fourth Exhibition of Le Groupe International de L'Art Figuratif, sponsored by the Asahi newspaper company.

May: Invited to exhibit in Fifth Contemporary Japanese Art Exhibition, and submits *At the Volcano: Three Birds* and *Flying Bird*.

September: Exhibits two works titled *Still Life*, *Pots with Cross* and *Two Pots* in Twenty-sixth Exhibition of the Shinseisaku Association.

1963(Shōwa 38) Age 58

May: Invited to exhibit in Seventh International Art Exhibition, Japan, and submits *Still Life*.

September: Exhibits *Corn and Fish*, *Window with Fish* and *Sakuradai* in Twenty-seventh Exhibition of the Shinseisaku Association.

1964(Shōwa 39) Age 59

March: Exhibits *Fish* in Fifth Exhibition of Le Groupe International de L'Art Figuratif held at the Matsuzakaya department store in Ueno, Tōkyō. During this spring moves to villa in the hills of Higashi Koiso in Ōiso, Kanagawa Prefecture.

May: Invited to exhibit in Sixth Contemporary Japanese Art Exhibition, and submits *Early Morning* and *Five-storied Pagoda*.

July: Exhibits *Dawn* and *Flowers* in First Taiyō Exhibition held at Galerie Nichidō in Ginza, Tōkyō. From this time on, Setsuko exhibits constantly in Taiyō Exhibition and other exhibitions organized by Galerie Nichidō. Solo show at the Matsuya department store in Ginza; exhibits paintings of Ōiso landscapes.

1965(Shōwa 40) Age 60

May: Invited to exhibit in Eighth International Art Exhibition, Japan, and submits *Dawn*. Travels in Hokkaidō.

September: Exhibits *In Praise of the Sun I* and *In Praise of the Sun II* in Twenty-ninth Exhibition of the Shinseisaku Association.

1966(Shōwa 41) Age 61

May: Invited to exhibit in Seventh Contemporary Japanese Art Exhibition, and

submits two versions of *Three Stems of Mimosa*.

September: Exhibits two works titled *Still Life in the Window* and *Birds Flocking* in Thirtieth Exhibition of the Shinseisaku Association.

1967 (Shōwa 42) Age 62

May: Invited to exhibit in Ninth International Art Exhibition, Japan, and submits *Flower of Eternity*.

September: Presents 216 works by husband Kōtarō to Hokkaidō, his hometown. On the basis of this collection, the Hokkaidō Museum of Art was established, followed by the Hokkaidō Kōtarō Migishi Museum of Art.

Exhibits *Egyptian Falcon* in Thirty-first Exhibition of the Shinseisaku Association.

1968 (Shōwa 43) Age 63

May: Invited to exhibit in Eighth Contemporary Japanese Art Exhibition, and submits *Approaching Night* and *Blue Morning*.

June: Two simultaneous solo shows at Nantenshi Gallery in Kyōbashi, Tōkyō, and Keiō Umeda Gallery in Shinjuku, Tōkyō. Exhibits series of paintings titled *Paean to the Sun* and other works.

December: Goes with her eldest son, Kōtarō, and his family to live in Cagnes in southern France.

1969 (Shōwa 44) Age 64

March: Participates in formation of Comprehensive Art Exhibition titled Ushio and organized by women artists. In first exhibition Setsuko shows four works from series *Paean to the Sun*, as well as other works.

1970 (Shōwa 45) Age 65

March: Exhibits *The Red Stairs in Cagnes*, *The Mountain Where the Mimosa Blooms*, *Cagnes Landscape*, *The House in Cagnes-sur-Mer* and three versions of *Flowers* in Second Ushio Exhibition.

Fig. 23.

With her grandson Tarō, in a restaurant of Southern France, 1971.

1971 (Shōwa 46) Age 66

March: Exhibits four paintings, including *Landscape in Southern France* (*A*) and thirteen pastel works in Third Ushio Exhibition.

1972 (Shōwa 47) Age 67

February: Exhibits a series of paintings titled *At Cagnes, Southern France*. Begins work on Venetian landscapes for Fourth Ushio Exhibition.

1974 (Shōwa 49) Age 69

February: Exhibits *Flying Birds*, *White Road*, *Wall with Graffiti* and *White Town in Spain* in Sixth Ushio Exhibition.

March: Solo exhibition at Galerie Taménaga in Paris. Moves into a farmhouse in village of Véron in Bourgogne, France.

April: Returns temporarily to Japan for solo show.

May: Solo exhibition *Flowers and Venice* held at the Mitsukoshi department store in Nihombashi, Tōkyō. Forty-two works shown, including *Little Canal*, *Stone Pavement*, *House on the Grand Canal* and *Red House*.

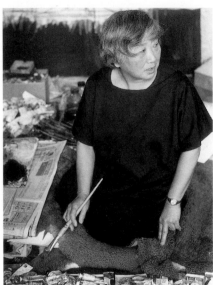

Fig. 24. In the atelier of Véron, 1979.

Fig. 25. Véron, 1979.

1975 (Shōwa 50) Age 70

February: Exhibits series of five paintings titled *Colloquy between Clouds and the Sea* in Seventh Ushio Exhibition. A book of her paintings, *Flowers and Venice: Setsuko Migishi*, published by Sansaisha.

May: Returns to Véron, Bourgogne.

1976 (Shōwa 51) Age 71

March: Exhibits *Flower I* and *Flower II* in Eighth Ushio Exhibition. Because of illness, returns to Japan to recuperate in Ōiso, Kanagawa Prefecture.

August: Completes series *Flowers* and returns to Véron.

October: Solo show of series of twenty-one small paintings titled *Flowers* at the Meitetsu Maruei department store in Ichinomiya.

1977 (Shōwa 52) Age 72

March: Exhibits *On the Bridge, White Water, Weather Vane in Véron* and *On the Grand Canal* in Ninth Ushio Exhibition. A new art museum, the Himalaya Art Museum, built in Nagoya with one room devoted exclusively to Migishi works.

June: Collection of Migishi essays titled *More Flowerlike than Flowers* published by Kyūryūdō.

September: Solo show at Galerie Nichidō in Ginza, Tōkyō, includes twenty-one small works titled *Flowers*.

1978 (Shōwa 53) Age 73

February: Exhibits *Road to the Square at Arles, Tree in Bourgogne, The Village Square at Arles* and *Flowering Bourgogne* in Tenth Ushio Exhibition.

1979 (Shōwa 54) Age 74

February: Exhibits *At Tonnerre, Twilight in Chablis, Dawn in Véron* and *Wheat Field in Bourgogne* in Eleventh Ushio Exhibition.

1980 (Shōwa 55) Age 75

February: Book *Paintings by Setsuko Migishi* published by Kyūryūdō. Exhibits *Approaching Thunder, The Monastery* and other works in Twelfth Ushio Exhibition.

May: Solo show at Galerie Taménaga in Paris.

August: Returns to Japan from France. Under the auspices of the Nihon Keizai newspaper company, a retrospective exhibition of about 100 works held at the Mitsukoshi department store in Nihombashi, Tōkyō. Exhibition tours in Niigata and Sapporo.

October: Solo show *Flowers and Bourgogne*, held in Nagoya at the Matsuzakaya department store, includes forty-three new works. Receives the Fourth Jin Hasegawa Commemorative Award for work *White River in Tonnerre*. The award commemorates the achievements of Jin Hasegawa, founder of Galerie Nichidō.

1981 (Shōwa 56) Age 76

March: Exhibits *Flowers, Winter in Véron* and *Véron in Winter* in Thirteenth Ushio Exhibition. *Wheat Field in Bourgogne* selected for Third Masterpieces Art Exhibition, Japan. Solo show at the Tenmaya department store in Hiroshima, includes nineteen works, dating from *On the Bridge* (1971) to recently executed paintings. Exhibition tours the Tenmaya establishments in Okayama, Kurashiki, Fukuyama and Mihara.

September: Book *Paintings by Setsuko Migishi* (*II*) published by Kyūryūdō. Solo

Fig. 26.
With her son Kōtarō, in the garden of Véron, 1979.

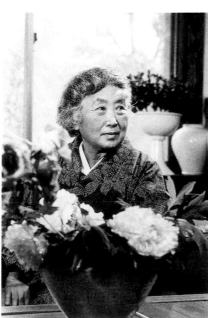

Fig. 27. Ōiso, 1981.
Photograph by Shihachi Fujimoto

show at Umeda Gallery, Osaka, includes thirty-six paintings executed in Europe; Show tours to the Iwataya department store in Fukuoka.

October: Serves as committee member for First Contemporary Women Artists' Exhibition (Dai-ikkai Gendai-no Joryū Gaka-ten), in which she exhibits *Flowers*. From this time exhibits regularly with this group.

1982 (Shōwa 57) Age 77

March: Exhibits five works, including *Spring Waters at Tonnerre*, *San Martin Canal* and *Flowers*, in Fourteenth Ushio Exhibition. In spring collapses from Ménière's disease caused by overwork.

November: Returns to Japan from France. Solo show at Galerie Nichidō includes twenty works titled *Flowers*.

1983 (Shōwa 58) Age 78

February: Collection of Migishi's essays, *The Yellow Notebook*, published by Kyū-ryūdō.

March: Exhibits two versions of *Flowers* and *The San Martin Canal with Maple Trees* in Fifteenth Ushio Exhibition. This is the last time she exhibits with the Ushio group.

July: Travels in Hokkaidō and visits Hokkaidō Kōtarō Migishi Museum of Art. Hospitalized for an intestinal operation at the Juntendō Hospital. Recuperates at Ōiso, Kanagawa Prefecture.

1984 (Shōwa 59) Age 79

March: Book *Setsuko Migishi's Flower Sketchbook* published by Kyūryūdō.

September: Leaves for France.

October: Solo show at Bara Gallery, Ginza, Tōkyō, and Royal Gallery, also in Ginza.

December: Exhibits *White Town in Spain* and *White Flowers* in exhibition *Creative '84: Ten Women Painters*, sponsored by the Asahi newspaper company and held at Yūrakuchō Asahi Gallery.

1985 (Shōwa 60) Age 80

August: Retrospective exhibition held at the Okazaki City Art Museum, under the auspices of the Chūnichi newspaper company. Eighty-six oil paintings and forty drawings shown. Exhibition tours until February 1986.

December: Solo show titled *White Flowers* at Tōhō Art in Ginza, Tōkyō, includes a series of twenty paintings titled *Flowers in Véron*. Participates in *Paris vu par les artistes japonais*, held at the Musée Carnavalet, exhibiting *Eiffel Tower* and *The House in the Sixteenth District, Paris*. Exhibition presented in Japan in 1986 respectively at the Museum of Modern Art, Kamakura, and the Mie Prefectural Art Museum.

1986 (Shōwa 61) Age 81

January: Exhibits *Eiffel Tower* in Women Artists' Exhibition 1986, held at the Takashimaya department store in Nihombashi, Tōkyō.

November: Decorated with the Third Order of Merit of the Order of the Sacred Crown for her distinguished cultural achievements.

1987 (Shōwa 62) Age 82

January: Exhibits *Capricious Waters (Venice)* in Women Artists' Exhibition 1987, held at the Takashimaya department store in Nihombashi, Tōkyō.

Autumn: Stays in Andalusia and begins a series of paintings on Spanish themes.

November: Exhibits *Eiffel Tower* in Eighth Beauty in Japan: Contemporary Women Artists' Exhibition (Dai-hachikai Nihon no Bi: Gendai Joryū Bijutsu-ten) held at Ueno-no Mori Art Museum.

1988 (Shōwa 63) Age 83

January: Exhibits *Hilltop* in Women Artists' Exhibition 1988, held at the Takashimaya department store in Nihombashi, Tōkyō.

June: Made honorary citizen of the city of Bisai; in commemoration of this event, the city also purchases one of her paintings.

October: *Setsuko Migishi* exhibition held at Galerie Taménaga, Paris.

1989 (Shōwa 64/Heisei 1) Age 84

January: Solo show at Bisai City Museum.

August: Exhibits seventy-three recent and new works in solo exhibition sponsored by the Asahi newspaper company and held at the Mitsukoshi department store in Nihombashi, Tōkyō. Exhibition tours to the Matsuzakaya department store in Nagoya and the Mitsukoshi department store in Ōsaka.

October: *Approaching Thunder* selected for *Our All-time Favorites—Western-style Art Masterworks of the Shōwa Period* (Shōwa no Yōga Hyakusen-ten), sponsored by the Asahi newspaper company and held at the Matsuya department store in Ginza, Tokyo. Solo show held at the Bisai City Museum to commemorate the city's thirty-fifth anniversary; includes thirty works executed since 1986.

1990 (Heisei 2) Age 85

January: Receives the 1989 Asahi Culture Prize for "sixty years of work as a painter of integrity and her achievements in advancing the cause of women painters." Exhibits *The Seine in Winter* in Women Artists' Exhibition 1990.

May: Exhibits early *Self-Portrait* in *Teenage Years of Famous Artists* (Mei-gakatachi no Jūdai), sponsored by the Asahi newspaper company and others. Show held at the Mitsukoshi department store in Nagoya.

October: Retrospective exhibition held at the Nagashima Museum in Kagoshima, Kyūshū; features sixty-eight representative paintings. Exhibition later shown at the Iwataya department store in Fukuoka.

November: *The Paintings of Setsuko Migishi 1990* published by Kyūryūdō.

I wish to express my gratitude to Hideo Takumi, whose chronology has been of immense help in compiling this overview of Setsuko Migishi's career.

Translated by Hideko Urushibara

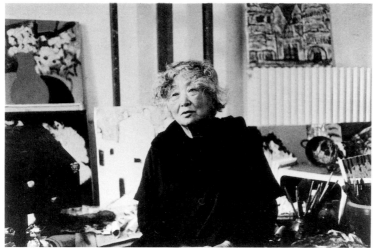

Fig. 28. Véron, 1987. Photograph by Hiroko Hayashi

Fig. 29. Migishi's house in Véron.

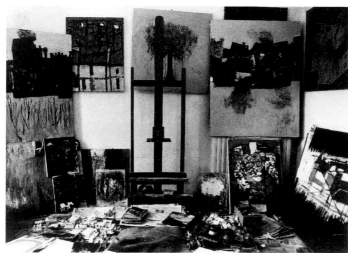

Fig. 30. Interior of Migishi's house in Véron.

Selected Bibliography

Compiled by Masatoshi Nakajima

1. Publications on Migishi's works

Painting

MIGISHI, SETSUKO & TOMINAGA, SŌICHI. *S. Migishi*. (Selected Contemporary Japanese Artists, Ser. II, No. 8.) Tōkyō : Bijutsu Shuppansha, 1954.

SERIZAWA, KŌJIRŌ ; OKUMURA, TOGYŪ; TAKUMI, HIDEO, *et al*. *Setsuko Migishi: Flowers and Venice*. Tōkyō: Sansaisha, 1975.

MIGISHI, SETSUKO & TAKUMI, HIDEO. *The Works of Setsuko Migishi: 1925–79*. (Includes chronology compiled by Hideo Takumi, catalog of works, and bibliography.) Tōkyō: Kyūryūdō, 1980.

MIGISHI, SETSUKO & TAKUMI, HIDEO. *The Works of Setsuko Migishi: Book 2, 1938–1980*. (Includes list of exhibitions compiled by Hideo Takumi, catalog of works, & catalog of works from the first book above.) Tōkyō: Kyūryūdō, 1981.

MIGISHI, SETSUKO. *A Drawing Book of Flowers*. Tōkyō: Kyūryūdō, 1984.

INOUE, YASUSHI; MIGISHI, SETSUKO; & ŌHARA, TOMIE. *The Works of Setsuko Migishi*. (Including "The Originality of Migishi-san" by Yasushi Inoue, "Notes on My Life Today" by Setsuko Migishi, and "Setsuko Migishi: Her Art and Personality" by Tomie Ōhara, as well as lists of published color plates of Migishi's works, and lists of main works, exhibitions, publications, and chronology compiled by Masatoshi Nakajima.) Tōkyō: Kyūryūdō, 1990.

Catalogs

Flowers and Venice: An Exhibition of Paintings by Setsuko Migishi. Mitsukoshi, May, 1974.

Hometown Perceived: An Exhibition of Paintings by Setsuko Migishi. Meitetsu Maruei Hyakkaten, October, 1976.

An Exhibition of Paintings by Setsuko Migishi. Galerie Nichidō, September, 1977.

Fifty-five Years of Painting: An Exhibition of Works by Setsuko Migishi. Nihon Keizai Shimbunsha, August, 1980.

An Exhibition of New Paintings by Setsuko Migishi. Matsuzakaya, October, 1980.

An Exhibition of Paintings by Setsuko Migishi. Tenmaya, March, 1981.

Works Painted in Europe by Setsuko Migishi. Umeda Museum of Modern Art & Iwataya, September, 1981.

"Flowers" : An Exhibition of Paintings by Setsuko Migishi. Galerie Nichidō, November, 1982.

An Exhibitions of New Paintings by Setsuko Migishi. Bara Gallery, October, 1984.

An Exhibition of Paintings by Setsuko Migishi. Royal Gallery, October, 1984.

An Exhibition of Paintings by Setsuko Migishi. (Ed. by the Museum of Modern Art, Kamakura.) Tōkyō Shimbun, August, 1985.

An Exhibition of Paintings by Setsuko Migishi. The Bisai City Museum, January, 1989.

An Exhibition of Paintings by Setsuko Migishi. Department I (Art Exhibitions), Cultural Projects Division, Asahi Shimbun, Tōkyō, August, 1989.

An Exhibition of New Paintings by Setsuko Migishi. The Bisai City Museum, October, 1989.

An Exhibition of Paintings by Setsuko Migishi. Nagashima Museum, October 1990.

2. The Writings of Setsuko Migishi

Books

MIGISHI, SETSUKO. *Wings of the Spirit of Beauty*. Tōkyō: Asahi Shimbunsha, 1949.

------------------. *Wings of the Spirit of Beauty*. Nagoya: Himalaya Art Museum, 1977.

------------------. *More Flowerlike than Flowers*. Tōkyō: Kyūryūdō, 1977.

------------------. *The Yellow Notebook*. Tōkyō: Kyūryūdō, 1983.

MIGISHI, SETSUKO as told to HAYASHI, HIROKO. *Flowers of Strife*. Tōkyō: Kōdansha, 1989.

Essays

MIGISHI, SETSUKO. "Memories," *Mizue*, No. 358 (December 1934) , 21-22.

------------------. "An Account of the Kanji Maeda Retrospective Exhibition," *Mizue*, No. 363 (May 1935), 15-16.

------------------. "Letter from the Studio," *Mizue*, No. 367 (September 1935), 19-21.

------------------. "Journey to the North," *Mizue*, No. 378 (August 1936), 22-23.

------------------. "A Woman's Face," *Zakkichō*, Vol. 1, No. 2 (November 1936), 30-31.

------------------. "The Compulsion to Paint," *Atelier*, Vol. XIII, No. 12 (December 1936), 59.

------------------. "Personal Memoranda," *Kokumin Bijutsu*, No. 1 (April 1937), 67-68.

------------------. "Remembered Faces," *Zakkichō*, Vol.II No. 9 (October 1937), 69-71.

------------------. "Miscellanies," *Mizue*, No. 399 (May 1938), 21-22.

------------------. "Journeys," *Atelier*, Vol. XV, No. 17, (December 1938), 76.

------------------. "Talking to Oneself," *Bi-no Kuni*, Vol. XV, No. 3 (March 1939), 72-73.

------------------. "Between the Lines," *Shinseisaku-ha*, No. 4 (November 1939), 40-41.

------------------. "Women Artists: The Meaning of the Term," *Tōkyō Shimbun* (January 29, 1947), 2 ("Culture" column).

------------------. "How to Use Oils to Enhance Oil Paints," *Bijutsu Techō*, No. 24 (December 1949), 18-19 ("Technical Notes" column).

------------------. "Vehicles," *Bijutsu Techō*, No. 34 (September 1950), 36 ("Things I Like Most" column).

------------------. "Husband-and-Wife Painters and Parents-and-Children Painters," *Geijutsu Shinchō*, Vol. III, No. 2 (February 1952), 129-131 (an autobiographical story).

------------------. "Unfortunate Picture," *Bungei Shunjū*, Vol. XXX, No.4 (March 1952), 19-20.

------------------. "Aspects of Painting That I Have Trouble With (Technical Classroom)," *Atelier*, No.306 (May 1952), 55-56.

------------------. "On Children's Art," *Shufu-no Tomo*, Vol. XXXVI, No. 8 (August 1952) , 59 (from *Atelier*).

------------------. "Thoughts Provoked by the Linden Tree," *Mainichi Shimbun* (February 5, 1953), 2 ("Arts and Sciences" column).

------------------. "Bush Clover," *Tankō*, No. 63 (September 1953), 77-78 (one of a group of essays under the title "The Seven Flowers of Autumn").

------------------. "Clothes with Crucifix," *Geijutsu Shinchō*, Vol. VI, No. 12 (December 1955), 91 ("Homage to Art" column).

------------------. "Sleeping Beauty," *Geijutsu Shinchō*, Vol. VII, No.10 (October 1956), 191.

------------------. "On the Painting of Haniwa," *Gendai-no Me* (newsletter of the National Museum of Modern Art), No. 35 (October 1957), 5 ("Contributing Artists" column).

------------------. "About Kōtarō Migishi," *Atelier* Supplement ("The Unknown Workbook of Kōtarō Migishi"), No. 39 (October 1957), 4.

------------------. "The Four Seasons of Our House," *Hōshun*, No. 50 (December 1957), 29-32.

------------------. "Haniwa," *Geijutsu Shinchō* (Special Edition: "The Plus and Minus Factors Actuating Contemporary Art"), Vol. X, No. 7, (September 1959), 152-153.

------------------. "A Certain Book (59): Benjamin Constant's *Adolphe*," *Asahi Shimbun* (March 8, 1962), 3.

------------------. "In Pursuit of an Ultimate Purpose," *Geijutsu Shinchō*, Vol. XVI, No. 8 (August 1965), 42 ("People" column).

------------------. "Memories" ("Reminiscences of Masao Ōshita"), *Bijutsu Shuppansha* (February 1967), 251-252.

------------------. "The Migishi Memorial Museum," *Nami*, No. 4 (October 1967), 5 (a drawing in pen-and-ink).

------------------. "Foolhardiness," *Asahi, Shimbun* (December 3, 1967), 18 ("When I Was Twenty" column).

------------------. "Total Solitude," *Nihon Keizai Shimbun* (April 27, 1968), 20 ("Friends and Acquaintances" column).

------------------. "Pleasure Trips in Southern France," *Asahi Shimbun* (March 20, 1969: evening edition), 7.

------------------. "Lonesome Journeys," *Missis*, Nos. 111-125 (January-December 1970), 6.

------------------. "From Paris," *Nihon Bijutsu*, No. 64 (February 1970), 33.

------------------. "From the House in Cagnes, Southern France" (in the catalog for the *Exhibition of the Works of Kōtarō Migishi*), *Tōkyō Shimbun* (May 1972).

------------------. "To the Sea," *Hanga Geijutsu*, No. 8 (January 1975), 112-113.

------------------. "Kōtarō Migishi and the Museum Built for Him" ("Setsuko Migishi and the Museum Built Out of Love") *Tsubomi*, No. 4 (September 1976), 85-92.

------------------. "Songs of the North," (Special Edition on Kōtarō Migishi, No. 1) *Sapporo Pirika*, No. 1 (December 1976), 12-13.

------------------. "Mr. Yamashita," *E* (Supplementary Edition, No. 3, "Takashi Yamashita"), (November 1979), 30-31.

------------------. "White River in Tonnerre," *E*, No. 201 (November 1980), 7 (a special feature on the 4th Jin Hasegawa Memorial Prize).

------------------. "Fifty Years" (in *The Complete Works of Kōtarō Migishi*), Asahi Shimbunsha (September 1983), 27-29.

------------------. "A Meeting with Oneself," *Asahi Shimbun* (October 2, 1989), 15 ("Heart" column).

Articles Based on Conversations

AOYAMA, YOSHIO, & MIGISHI, SETSUKO. "Sunday Dialog," *Nihon Keizaui Shimbun*, (August 7, 1955: evening edition), 4.

HAYASHI, TAKESHI; KOISO, RYŌHEI; MIGISHI, SETSUKO; OKAMOTO TARŌ; ASAKURA, SETSU; & ŌKUBO, TAI. "Twentieth Century Art," *Bungei*, Vol. XII, No. 15 (November 1956: supplement), 106-111.

MIGISHI, SETSUKO & TAKEBAYASHI, KEN. "Casual Encounters," *Bijutsu Techō*, No. 145 (August 1958), 66-72.

MIGISHI, SETSUKO; TAKUMI, HIDEO; & FUJIMOTO, SHŌZŌ. "A Certain Day's Conversation," *Sansai*, No. 322 (September 1974), 61-63.

MIGISHI, SETSUKO & YAMAZAKI, KAZUYOSHI. "A Visit to an Artist: Setsuko Migishi," *Nihon Bijutsu*, No. 111 (September 1974), 42-48.

"Living, Loving and Painting" (an interview), *Vision*, Vol. IV, No. 9 (September 1974), 101-104 (in "A Woman of Ardor: The Painter Setsuko Migishi, Her Life and Works").

"On Flowers" (an interview), *Art Vision*, Vol. XII, No. 1, (January 1982), 64-65 (in "Setsuko Migishi: The Yearning for Beauty").

"Painting Paris Scenes, and the Return to Japan" (an interview), *Art Top*, No. 90 (December 1985), 122-123 (in "Setsuko Migishi: An Invitation to Beauty").

"Paris Landscapes: New Challenges at Eighty Years of Age" (an interview), *Gekkan Bijutsu*, No. 123 (December 1985), 94-96 (in "An Exhibition of Paintings by Setsuko Migishi" covering sixty years of work in the world of art.)

MIGISHI, SETSUKO as told to Hiroko Hayashi. "This Road," 1-50, *Chūnichi Shimbun* (April 30-June 28, 1986).

MIGISHI, SETSUKO as told to Hiroko Hayashi. "The Way I Remember It," 1-20, *Tōkyō Shimbun* (July 23-September 10, 1986: evening edition).

MIGISHI, SETSUKO as told to Mamoru Yonekura. "Between the Lines: Setsuko Migishi," *Asahi Shimbun* (August 11, 1989: evening edition). 3.

"Three Years of Painting in Paris, Spain and Italy" (an interview), *Art Vision*, Vol.XVII, No. 2 (February 1989), 21-24.

"The Painter Setsuko Migishi" (MOA interview), *Kikan MOA*, No. 32 (October 1989), 30-34.

MIGISHI, SETSUKO as told to Tsuneko Ogawa. "Roads," *Yomiuri Shimbun* (July 7, 1990: evening edition), 5.

3. Articles and Other Writings on Setsuko Migishi

SAWA, HAJIME. "Setsuko Migishi: A Profile on the Artist," *Mizue*, No. 378 (August 1936), 11, 14.

ŌKUBO, TAI. "Setsuko Migishi," *Atelier*, No. 256 (April 1948), 36, 43.

FUNADO, KŌ. "Setsuko Migishi, Woman and Painter," *Bijutsu Techō*, No. 5 (May 1948), 20–23 (in "Visits to Ateliers," No. 5).

HIJIKATA, TEIICHI. "Setsuko Migishi," in the catalog for the exhibition of *Representative Modern Paintings by 15 Japanese Artists*, Yomiuri Shimbunsha (January 1950), 7.

"Dissolution of a Marriage: The Case of Setsuko Migishi," *Shūkan Asahi*, Vol. LVIII, No. 46 (November 1, 1953), 3–11.

TAJIKA, KENZŌ. "Setsuko Migishi: My Opinions on People," *Nihon Keizai Shimbun*, (April 17, 1955), 10.

SHIMIZU, KON. "Setsuko Migishi: A Portrait Executed in One Stroke of the Pen," *Asahi Shimbun*, (December 15, 1956: evening edition), 1.

UEMURA, TAKACHIYO. "The Drawings of Setsuko Migishi," *Sansai*, No. 94 (December 1957), 32.

TAKEBAYASHI, KEN. "Casual Encounters: Setsuko Migishi," *Bijutsu Techō*, No. 145 (August 1958), 66–72.

HAMAMURA, JUN. "A Short Treatise on Setsuko Migishi," *Mizue*, No. 670 (February 1961), 73–76 & 82.

ONODA. "A Visit with Setsuko Migishi," *Nihon Bijutsu*, No.23 (April 1962), 34–35.

TAKEDA MICHITARŌ. "Setsuko Migishi: My Life As an Artist," *Kokusai Shashin Jōhō*, No. 169 (February 1965), 48–49.

"Setsuko Migishi: Woman of the Times," *Yomiuri Shimbun* (August 15, 1965), 2.

TAKEDA, MICHITARŌ. "The Tenacity of Setsuko Migishi," *Geijutsu Shinchō*, Vol. XVI, No. 11 (November 1965), 93–95.

SHINGAI, HIROSHI. "Mien and Mind (No. 9): Setsuko Migishi," *Tōkyō Shimbun* (July 4, 1967: evening edition), 1.

TANAKA, JŌ: "This Person: Setsuko Migishi," *Yomiuri Shimbun* (September 5, 1968), 18.

AWASHIMA, MASAKICHI. "Setsuko Migishi's Paintings on Glass," *Geijutsu Shinchō*, Vol. XXI, No.1 (January 1970), 98.

SATŌ, AIKO. "Setsuko Migishi" in "History of Modern Japanese Women, No.6 (Art)," *Kajima Kenkyūjo Shuppankai* (July 1970), 227–250.

OGAWA, MASATAKA. "Paintings of Southern France (3): Setsuko Migishi," *Asahi Shimbun* (August 22, 1973: evening edition), 5.

"Setsuko Migishi Returns from France for the First Time in Six Years," *Mainichi Shimbun* (May 22, 1974), 5.

OGIYA, SHŌZŌ. "Austere Flowers," *Nihon Bijutsu*, No.109 (July 1974), 96–99 (with a dedication to an *Exhibition of the Works of Setsuko Migishi*).

"Setsuko Migishi," *Sansai*, No.322 (September 1974), 55–63.

YAMAZAKI, KAZUYOSHI. "A Visit to an Artist: Setsuko Migishi," *Nihon Bijutsu*, No.111 (September 1974), 42–48.

TAKUMI, HIDEO; MIZUGAMI, KYŌHEI; SHIBAKI, YOSHIKO; & SATOMI, KATSUZŌ. "A Woman of Ardor: The Painter Setsuko Migishi, Her Life and Works," *Vision*, Vol. IV, No.9 (September 1974), 93–110.

OGAWA, MASATAKA. "On Setsuko and Kōtarō Migishi," *Gekkan Vision*, Vol.V, No.4 (May 1975), 69–74.

KUWABARA, SUMIO. "Japanese Aesthetics," *Art Top*, No.29 (July 1975), 98 (in the "Top Gallery" column).

"Faces (No.217): Setsuko Migishi," *Yomiuri Shimbun*, (August 12, 1976: evening edition),1.

TANAKA, JŌ. "Setsuko Migishi and the Painting 'Birds Flocking,'" *Yomiuri Shimbun* (July 31, 1977), 25 (in "The Four Seasons of Japan").

HASEGAWA, CHIEKO: "A Visit to Véron: Setsuko Migishi and Her Painted Flowers 'Wherein Eternity is Enclosed,'" *E*, No. 164 (October 1977), 14, & 16–17 ("This Month's Exhibitions" column).

TAKI, TEIZŌ: "Speaking Somewhat Perversely ...," *Gekkan Vision*, Vol. VII, No. 9 (November 1977), 58–67.

KUSANO, SHINPEI; SATA, INEKO; HIRANO, KYŌKO; & TAJIKA, KENZŌ. "Setsuko Migishi: A Special Feature," *Art Top*, No. 56 (April 1980), 11–48.

BOUILLOT, ROGER. "Migishi: Flower of the Earth," *Tonus* (May 28, 1980)

MIYAKE, SHŌTARŌ. "Setsuko Migishi and the Will towards Beauty," *Sansai*, No.395 (August 1980), 4–33.

SHIBAKI, YOSHIKO & UEMURA, TAKACHIYO. "Fifty-five Years of Painting: An Exhibition of Setsuko Migishi's Paintings," *Gekkan Bijutsu*, No.60 (September 1980), 57-64.

IMAIZUMI, ATSUO. "About Setsuko Migishi," *E*, No. 201 (November 1980), 2-7 (as part of a special edition marking the 4th Jin Hasegawa Memorial Prize).

"People and Their Work: Setsuko Migishi," *Nihon Keizai Shimbun* (December 2, 1980), 27.

FUJIMOTO, SHIHACHI. "Setsuko Migishi," *in Artists in Their Studios* (published by Shūeisha, June, 1982), 137.

YAMASHITA, TAKASHI. "To Setsuko Migishi," *E*, No. 225 (November 1982), 2-4.

MINAMIKAWA, SANJIRŌ. "Setsuko Migishi," *in Artists in Their Studios* (published by Asahi Shimbunsha, March 1983), 148 -149.

"Japanese Artists Living in Europe, No.8: Setsuko Migishi," *Gekkan Bijutsu*, No. 83 (August 1982), 137-141.

"On the Occasion of an Exhibition of Setsuko Migishi's Paintings," *Art Vision*, Vol. XIV, No.1 (March 1985), 46-50.

TAKUMI, HIDEO & FUJIMOTO, SHŌZŌ. "Setsuko Migishi: A Special Feature," *Sansai*, No. 456 (September 1985), 104-111,

KATAOKA, TAMAKO. "On Being Covered with Sparks from Passion's Fire," *Art Top*, No. 90 (December 1985), 120-123.

"An Exhibition of the Works of Setsuko Migishi Covering Her Sixty Years of Painting," *Gekkan Bijutsu*, No.123 (December 1985), 94-98.

MIGISHI, SETSUKO & OTA, YASUTO. "Talks with Artists: Setsuko Migishi and Her Works," *Kikan Mizue*, No. 937 (December 1985), 42-57.

TANAKA, JŌ. "Setsuko Migishi Challenges Paris, 'the Golden City,'" *Gekkan Bijutsu*, No. 129 (June 1986), 214-220 (the 38th of the series "A Hundred Stories" dealing with the painting world of the postwar period, as seen through the eyes of art reporters).

HORIO, MAKIKO. "Kōtarō and Setsuko Migishi: The Solitary Clowns," in "The Artists' Primitive Landscapes" (from the "Sunday Museum"), Nippon Hōsō Shuppan Kyōkai (September 1986), 121-161.

OKUNO, TAKEO & FUKUOKA, AKIRA. "Setsuko Migishi," *Art Vision*, Vol. XVII, No. 2 (February 1989), 2-29.

SHIN. "Setsuko Migishi: A Lifetime of Painting," *Yomiuri Shimbun* (February 16, 1989), 15 (in the "Family and Daily Life" column).

YONEKURA, MAMORU. "Between the Lines: Setsuko Migishi Speaks," *Asahi Shimbun*, (August 11, 1989: evening edition), 3.

OKUDA, YUTAKA. "People: Setsuko Migishi," *Sankei Shimbun* (August 22, 1989), 3.

OKABE, MASAYUKI. "Approaching Thunder," in the catalog for the exhibition of *100 Selected Western-style Paintings of the Shōwa Period* (*Shōwa-no Yōga Hyakusen-ten*), Asahi Shimbun, Department I (Art Exhibitions), Cultural Projects Division, (October 1989), 175.

"Setsuko Migishi: Her Fervent Pursuit of Living and Painting," *Asahi Shimbun* (January 1, 1990), 11 (in the column "Recipients of the Asahi Culture Prize").

"Setsuko Migishi," *Missis*, No. 416 (February 1990), 138-141.

AKIYAMA, SHŌTARŌ. "Artists of Contemporary Japan: Setsuko Migishi," *Gekkan Bijutsu*, No.173 (February 1990), 73-75.

HANDA, SHIGEO. "Setsuko Migishi" & "Festival: In Celebration of Tōwa Kensetsu," *E*, No.314 (April 1990), 45 (a column presenting the *Kasama Nichidō Museum of Art Selected Masterpieces Exhibition*).

MAKINO, KEN'ICHIRŌ. "Setsuko Migishi and the Painting 'Fish and Incan Pot,'" *Shōwa no Bijutsu* (Chronicle of Art), Vol. III. 1946-1955, Mainichi Shimbunsha (June 1990), 100.

OGAWA, TSUNEKO. "Roads: Setsuko Migishi," *Yomiuri Shimbun* (July 7, 1990: evening edition), 5.

TANUMA, TAKEYOSHI. "Afterimages in My Mind: Setsuko Migishi," *Tōkyō Shimbun* (July 12, 1990: evening edition), 9.

Translated by Hideko Urushibara